THE COMPLETE GUIDE TO
DRAWING
MANGA + COMICS

MANGA ART BY
"LIGHTNING-FAST"
LEO CAMPOS

SUPERHERO ART
BY "ASTOUNDING"
ANTHONY WILLIAMS

FANTASY ART BY
"SWASHBUCKLING"
SEB CAMAGAJEVAC

SCIENCE FICTION ART
BY "NO NONSENSE"
NIGEL DOBBYN

HORROR ART BY
"DYNAMIC"
DAVID BELMONTE

ARCTURUS

ARCTURUS

This edition published in 2024 by Arcturus Publishing Limited
26/27 Bickels Yard, 151–153 Bermondsey Street,
London SE1 3HA

Text: Lisa Regan and Joe Harris
Illustrations: Leo Campos (Beehive Illustration) pages 8–33; Anthony Williams pages
 34–57; Nigel Dobbyn (Beehive Illustration) pages 58–79 and 112–113; Seb Camagajevac
 (Beehive Illustration) pages 80–103 and 124–127; David Belmonte (Beehive Illustration)
 pages 104–111 and 114–123.
Design: Notion Design
Editor: Lucy Doncaster
Managing Editor: Joe Harris
Design Manager: Jessica Holliland

ISBN: 978-1-3988-4176-5
CH012077US

Printed in China

Supplier 29, Date 0524, Print Run 00006121

CONTENTS

THE WORLD OF COMICS

WHETHER YOU'RE A MILD-MANNERED AMATEUR ARTIST OR A SUPERHERO OF COMIC ILLUSTRATION, THIS BOOK WILL HELP YOU TO TAKE THINGS TO THE NEXT LEVEL. WE'VE DRAWN TOGETHER A PANTHEON OF AMAZING ARTISTS TO GIVE YOU EXPERT ADVICE ABOUT FIVE DIFFERENT COMIC ART GENRES.

MANGA COMICS

"Manga" isn't really a genre so much as a nationality, since all comics from Japan fall into this category. Modern manga first emerged in the wake of World War II, during the American occupation of Japan. The style was initially influenced by American cartoonists such as Walt Disney, but it has since developed an entirely unique approach.

SUPERHERO COMICS

Superheroes first exploded onto the American comics scene in the 1930s and 40s. Superman, the first of these larger-than-life characters, arrived in Action Comics #1 in 1938. Superheroes made such a huge impact on the medium that today, many people equate comics with superhero stories.

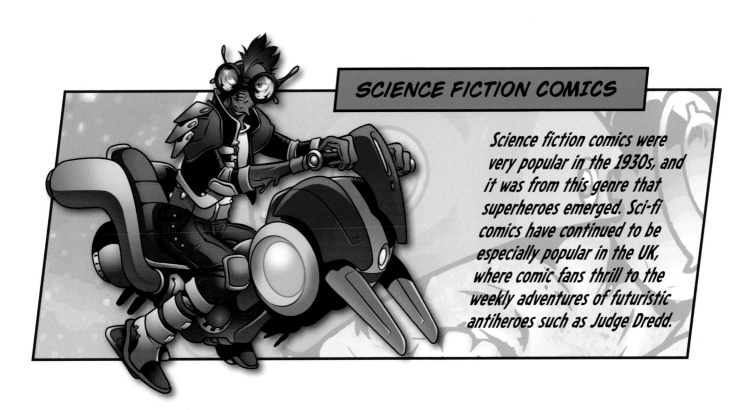

SCIENCE FICTION COMICS

Science fiction comics were very popular in the 1930s, and it was from this genre that superheroes emerged. Sci-fi comics have continued to be especially popular in the UK, where comic fans thrill to the weekly adventures of futuristic antiheroes such as Judge Dredd.

FANTASY COMICS

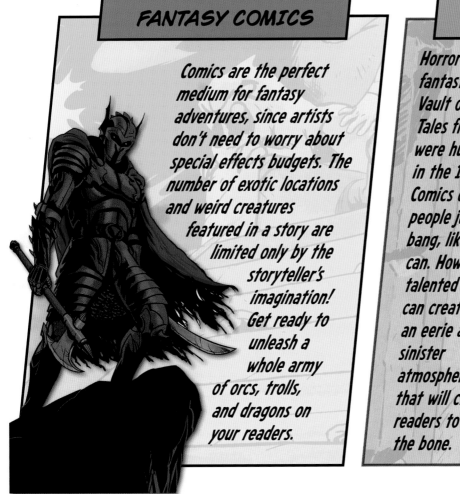

Comics are the perfect medium for fantasy adventures, since artists don't need to worry about special effects budgets. The number of exotic locations and weird creatures featured in a story are limited only by the storyteller's imagination! Get ready to unleash a whole army of orcs, trolls, and dragons on your readers.

HORROR COMICS

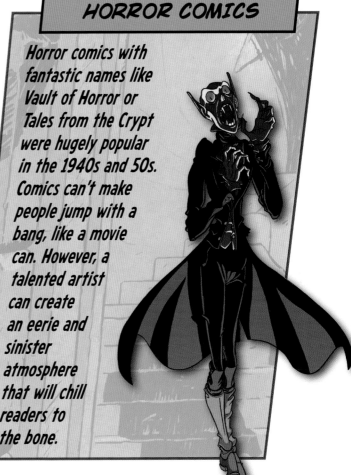

Horror comics with fantastic names like Vault of Horror or Tales from the Crypt were hugely popular in the 1940s and 50s. Comics can't make people jump with a bang, like a movie can. However, a talented artist can create an eerie and sinister atmosphere that will chill readers to the bone.

TOOLS OF THE TRADE

YOU DON'T NEED LOTS OF EXPENSIVE EQUIPMENT TO START CREATING COMICS. THE MOST IMPORTANT TOOL IS YOUR OWN IMAGINATION!

PENCILS

Soft (B, 2B) pencils are great for drawing loosely and are easy to erase. Fine point pencils are handy for adding detail.

ERASERS

A kneaded eraser molds to shape, so you can use it to remove pencil from tiny areas. Keep a clean, square-edged eraser to hand, too.

PENS

An artist's pens are his or her most precious tools! Gather a selection with different tips for varying the thickness of your line work.

PAPER

Good-quality paper will make your artwork look professional, but you can draw your rough sketches on any scrap of paper to hand.

FINE LINE AND BRUSH PENS

Fine line pens are excellent for small areas of detail. Brush pens are perfect for varying your line weight or shading large areas.

CIRCLE TEMPLATES

Very few people can draw a perfect circle freehand, so a set of circle templates is a good buy. If you don't have any templates, you can draw round various everyday items, such as coins, cups, and bottle lids, to create your circles.

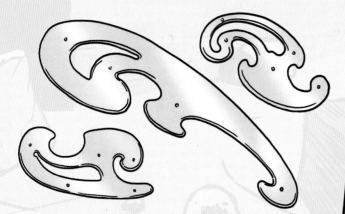

CURVES

A set of artist's curves is an inexpensive aid to drawing curved shapes of various sizes and angles. Many sets include circular templates cut out of the centers of the curves so they can be used for drawing circles too.

MANGA COMICS

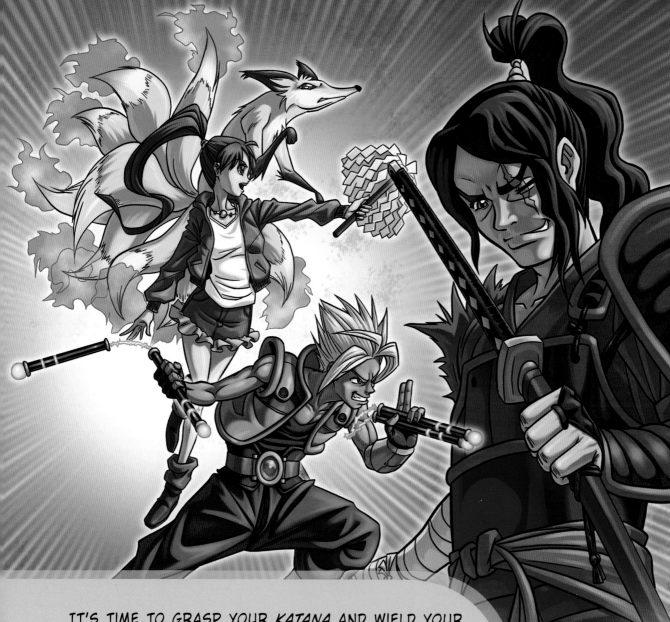

IT'S TIME TO GRASP YOUR *KATANA* AND WIELD YOUR *NUNCHAKUS*! THIS CHAPTER WILL SET YOU ON THE PATH TO BECOMING A BLACK BELT IN THE JAPANESE ART OF MANGA.

Manga comics can be about the same themes that appear in other comic genres—superheroes, science fiction, or fantasy. But they also have something that sets them apart as being uniquely Japanese! The manga approach uses many different techniques to European and American comics.

In this chapter, you will find tutorials about drawing manga faces and bodies, which uses different proportions from other forms of comic drawing (for non-manga proportion rules and other tips, turn to pages 124–127). There are also sections covering the Japanese approach to drawing eyes, hair, and facial expressions.

Manga comics use super-cool, stylized ways of showing motion. Once you have studied the manga approach, you may find that you can adapt elements of it when drawing in a non-Japanese style.

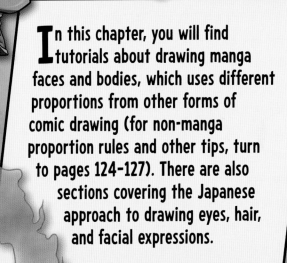

DRAWING HUMAN FIGURES

IT'S IMPORTANT TO THINK ABOUT PROPORTIONS WHEN DRAWING YOUR MANGA CHARACTERS. IF YOUR FIGURES' ARMS OR LEGS ARE THE WRONG LENGTH, THOSE BASIC ERRORS WILL STICK OUT LIKE A SORE THUMB!

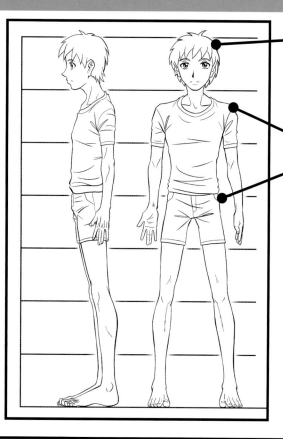

HEADS
Think of your characters' heights in terms of a number of "heads." A typical manga character is about seven heads tall.

SHOULDERS AND HIPS
Male characters are broadest at their shoulders. Female characters are broadest at their hips.

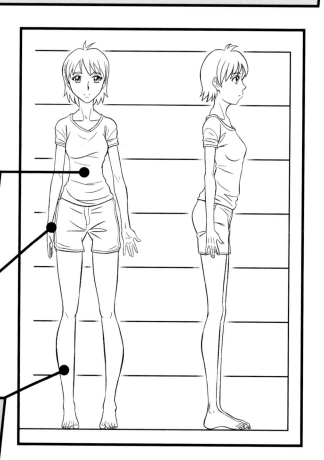

TORSOS
The average character's torso measures about two and a half head lengths.

ARMS
Arms reach from the shoulder down to the midpoint of the thigh. Be careful not to give your characters apelike arms!

LEGS
Manga characters' legs measure about four head lengths.

DRAWING HEADS

BY REMEMBERING A FEW SIMPLE RULES, YOU CAN MAKE SURE THAT YOUR FACES LOOK APPEALING. THIS WILL ALSO HELP WITH KEEPING FACES CONSISTENT FROM ONE PANEL TO THE NEXT.

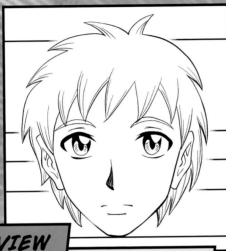

FRONT VIEW

In manga, as in real life, eyes are positioned about halfway down the head. But manga eyes are much larger than real ones!

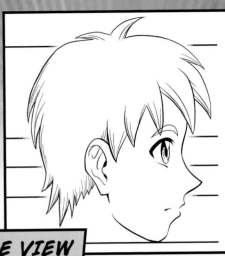

SIDE VIEW

Manga noses are almost invisible when shown head-on. From the side, they are cute and pointed, extending for roughly one eye-height.

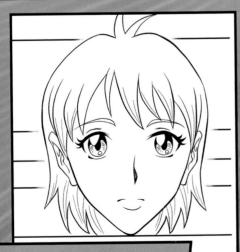

BOYS AND GIRLS

Male and female characters both have slim faces. Girls' faces tend to be narrower, with a more pointed chin. They also have longer eyelashes.

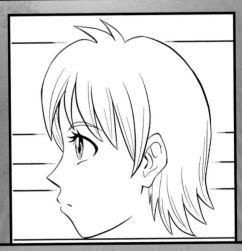

EYEBROWS AND EARS

In manga, both male and female eyebrows are narrow and gently arched. Ears extend from the top of the eyes to the bottom of the nose.

A MONSTER TRAINER

IT'S TIME TO TACKLE YOUR FIRST MANGA CHARACTER! MEET OUR MAGICAL TRAINER, TOKIKO, AND HER TAME MONSTER. THE CREATURE IS A KITSUNE, A MYTHOLOGICAL FOX WITH SUPERNATURAL ABILITIES. KITSUNES HAVE MANY TAILS, WHICH SHOW THEIR AGE AND POWER.

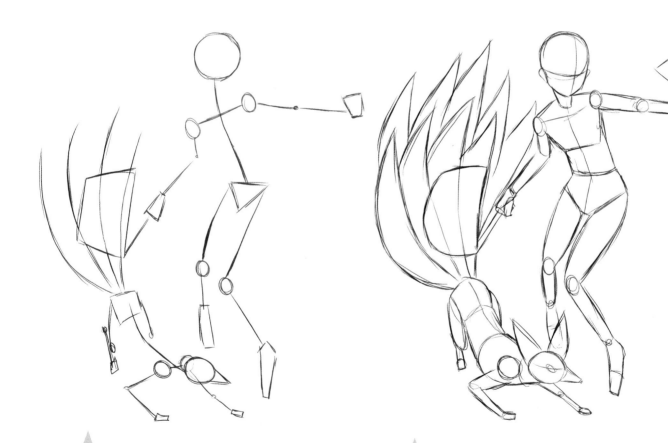

1 All your sketches should start with a wireframe. This allows you to get the stance and proportions correct.

2 Roughly sketch in all the elements of the image, from the *kitsune*'s nine tails to the trainer's talismans. She is carrying a magical wand with streamers, called an *ounusa*.

3 When the proportions are correct, flesh out the figure with clothes and features. Add a high ponytail for dramatic effect and chunky boots to contrast with her frilled skirt. This girl means business!

4 Draw the final details of your image, including the flames at the *kitsune*'s feet. Pencil in folds on the clothes to give the picture movement and texture. Add an inscription on the trainer's *ofuda*—the cards held in her left hand.

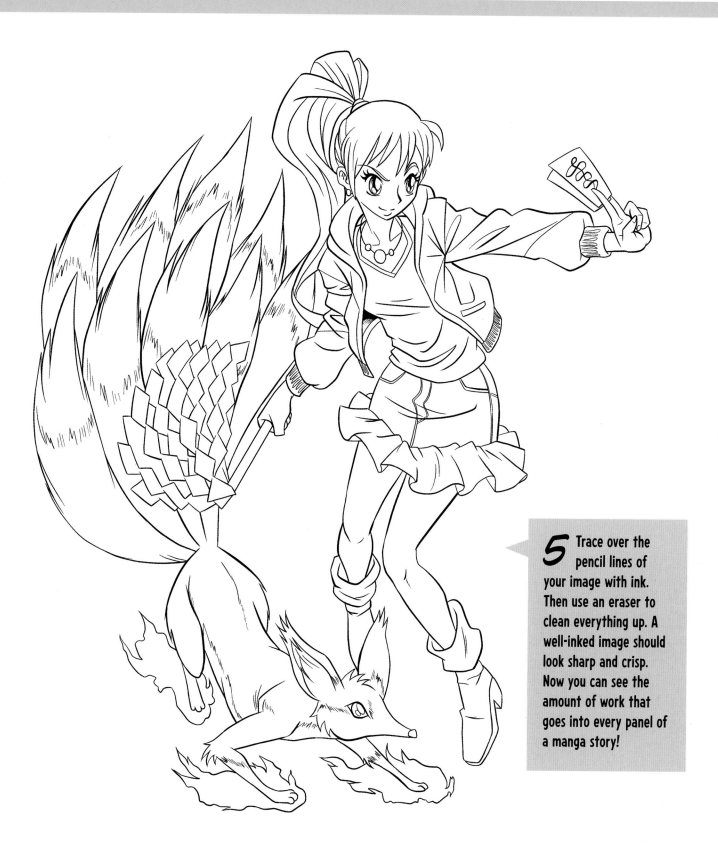

5 Trace over the pencil lines of your image with ink. Then use an eraser to clean everything up. A well-inked image should look sharp and crisp. Now you can see the amount of work that goes into every panel of a manga story!

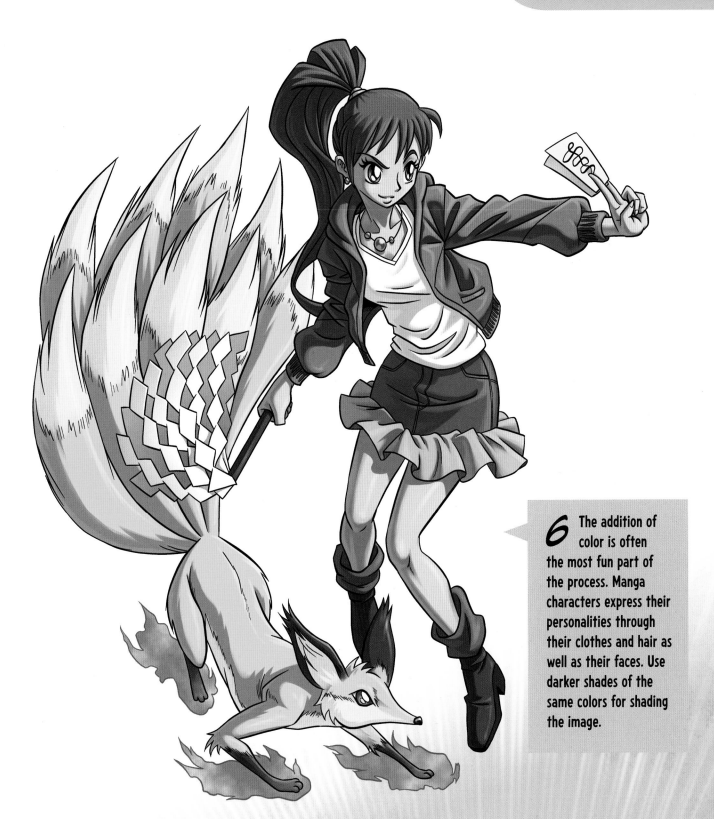

6 The addition of color is often the most fun part of the process. Manga characters express their personalities through their clothes and hair as well as their faces. Use darker shades of the same colors for shading the image.

MANGA EYES

EYES ARE THE MOST IMPORTANT FEATURES ON A MANGA FACE. THEY ARE USED TO SHOW EMOTIONS AND ALSO HELP TO MAKE CHARACTERS LOOK LIKABLE AND SYMPATHETIC.

HAPPY EYES
Wide eyes and high eyebrows show happiness. The eyes are very reflective, and the bottom lids curve upward.

SADNESS
Sad characters tend to have actual tears in their eyes. Lower the eyelids and drop the outer eyebrows.

EMBARRASSMENT
The blush lines say "Cringe!" and a sideways glance adds to the impression that this character is feeling shame.

ANGER
The inner eyebrows are dramatically lowered to depict fury. The pupils are small and darker than usual.

FEAR/SHOCK
The contracted pupils have almost disappeared here, but the eyes themselves are large and wide with fear.

MANGA HAIR

HAIRSTYLES CAN SAY A LOT ABOUT A MANGA HERO OR HEROINE. GENERALLY SPEAKING, THE BIGGER THE HAIR, THE WILDER THE CHARACTER!

SPIKY HAIR

Have fun with thick, spiked hair. Frame the face first, and then let it flow backward with jagged tufts.

SMART HAIR

Some manga characters have more realistic hairstyles. If the hair is black, add some white highlights.

RIBBONS

In manga, even tough girls love ribbons! Ponytails are a great device for showing movement.

WINDBLOWN HAIR

It's very common in manga to show hair being blown about by the wind.

HOW TO DRAW
A MARTIAL ARTIST

MOST MANGA FANS LOVE A FIGHT SCENE! CAPTURING A MARTIAL ARTIST IN ACTION CAN BE TRICKY. HOWEVER, IF YOU PAY CAREFUL ATTENTION TO GETTING THE WIREFRAME RIGHT, EVERYTHING ELSE WILL FALL INTO PLACE. OUR FIGHTER, KAZUO, IS WIELDING ENERGY NUNCHAKUS.

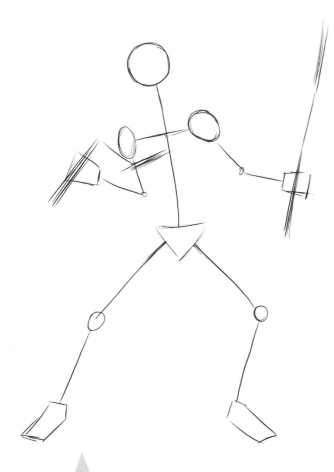 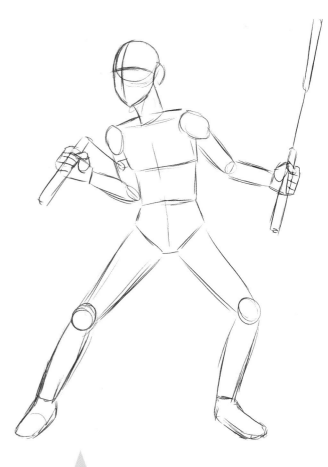

1 The fighting stance is well-balanced, with legs apart, arms wide, and feet planted securely but ready to spring.

2 Our fighter may be tough, but like most manga characters, he has a slim build. Take note of how the hands are drawn holding the weapons realistically.

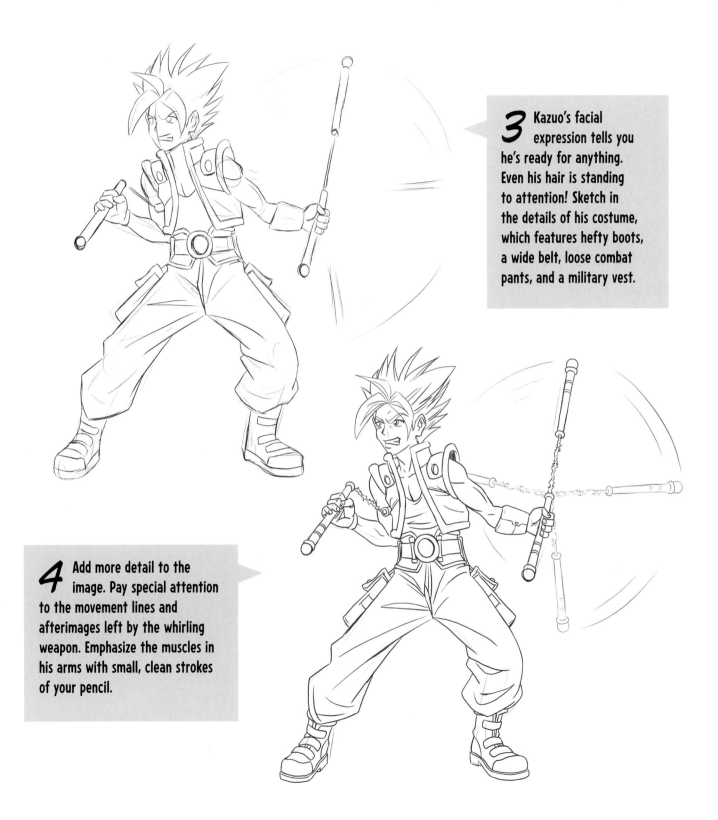

3 Kazuo's facial expression tells you he's ready for anything. Even his hair is standing to attention! Sketch in the details of his costume, which features hefty boots, a wide belt, loose combat pants, and a military vest.

4 Add more detail to the image. Pay special attention to the movement lines and afterimages left by the whirling weapon. Emphasize the muscles in his arms with small, clean strokes of your pencil.

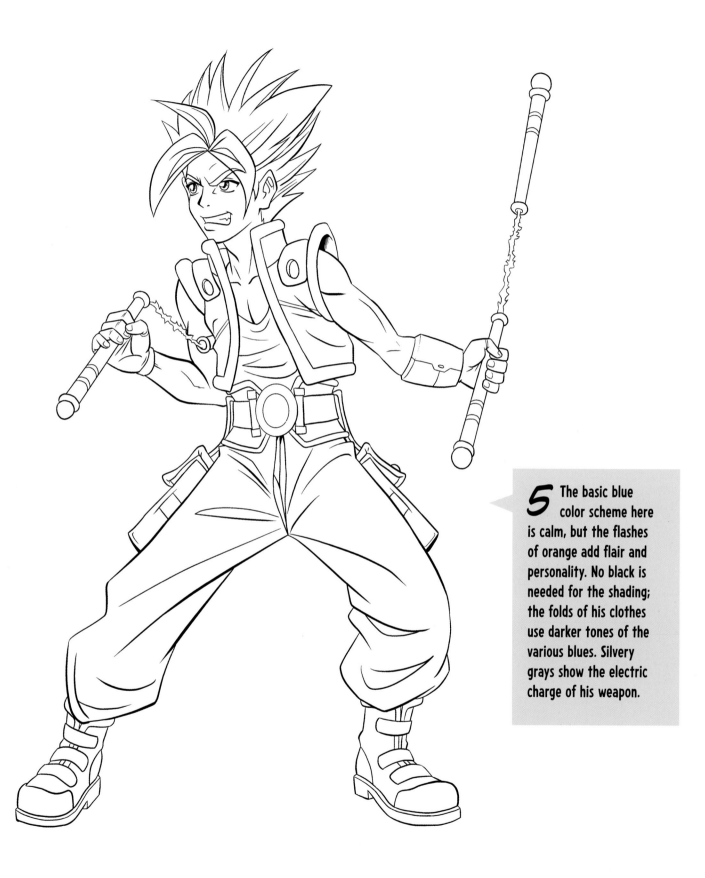

5 The basic blue color scheme here is calm, but the flashes of orange add flair and personality. No black is needed for the shading; the folds of his clothes use darker tones of the various blues. Silvery grays show the electric charge of his weapon.

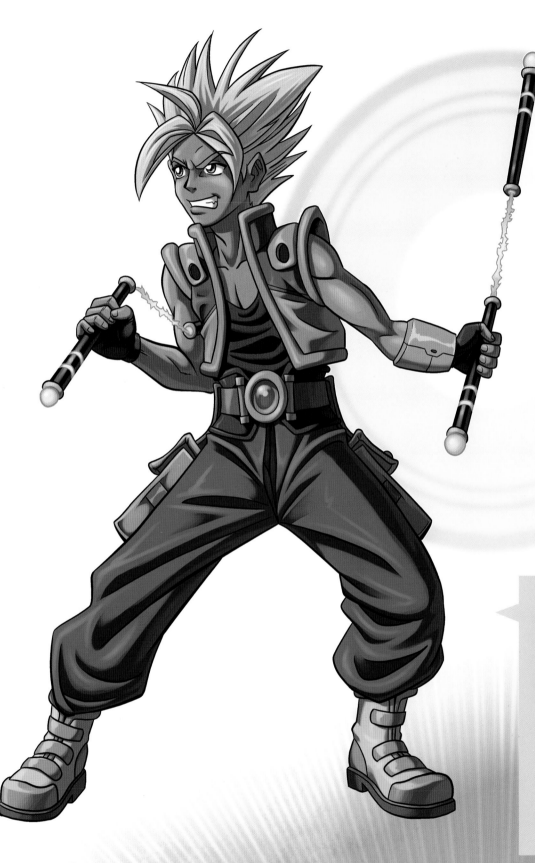

6 Carefully ink over your pencil marks. It's important to get his facial expression right, since that is what the reader's eye will be drawn to. His teeth are gritted, but he is smiling slightly. His arched eyebrows show that he is angry, but perhaps he is relishing the fight.

SHOWING EMOTIONS

MANGA HAS ITS OWN WAYS OF SHOWING WHAT PEOPLE ARE FEELING. NOTE THAT THE EMOTIONS ARE CONVEYED BY BOTH THE CHARACTERS' EXPRESSIONS AND BY THE BACKGROUNDS.

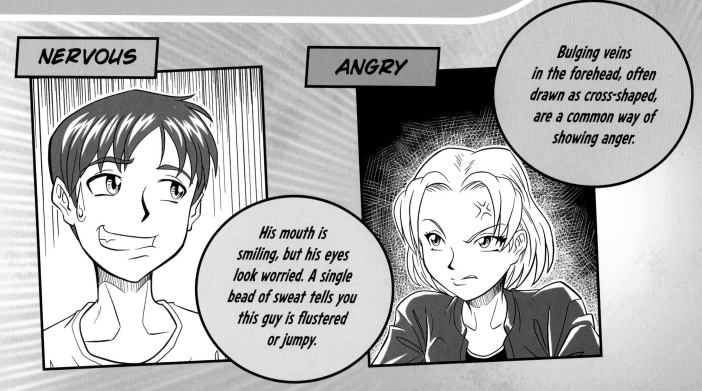

NERVOUS

ANGRY

Bulging veins in the forehead, often drawn as cross-shaped, are a common way of showing anger.

His mouth is smiling, but his eyes look worried. A single bead of sweat tells you this guy is flustered or jumpy.

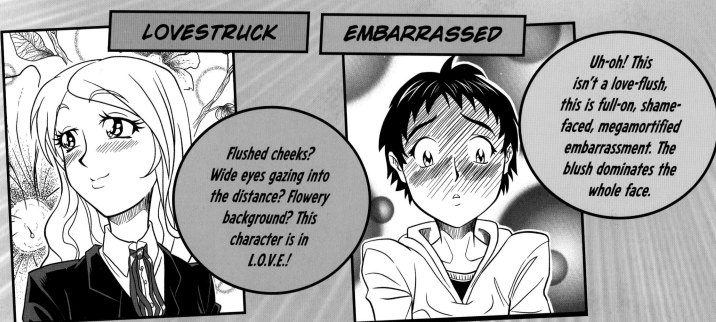

LOVESTRUCK

EMBARRASSED

Uh-oh! This isn't a love-flush, this is full-on, shame-faced, megamortified embarrassment. The blush dominates the whole face.

Flushed cheeks? Wide eyes gazing into the distance? Flowery background? This character is in L.O.V.E.!

CHIBI CARTOONS

IN MANGA, CHARACTERS' EMOTIONS ARE SOMETIMES SHOWN IN AN EXAGGERATED WAY BY DRAWING THE CHARACTERS AS CHIBIS FOR ONE OR MORE PANELS. CHIBIS ARE TINY AND CHILDLIKE, WITH A HEAD THAT'S ALMOST AS LONG AS THEIR BODY. THEY USUALLY HAVE NO NOSE!

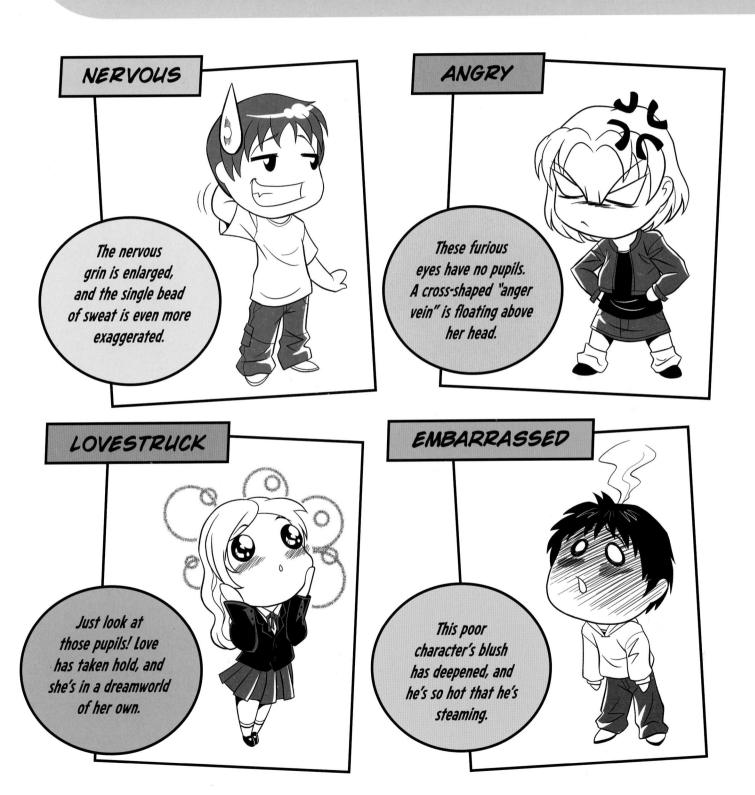

NERVOUS

The nervous grin is enlarged, and the single bead of sweat is even more exaggerated.

ANGRY

These furious eyes have no pupils. A cross-shaped "anger vein" is floating above her head.

LOVESTRUCK

Just look at those pupils! Love has taken hold, and she's in a dreamworld of her own.

EMBARRASSED

This poor character's blush has deepened, and he's so hot that he's steaming.

THE DARK RONIN

TAKE A STEP INTO JAPANESE HISTORY WITH THIS TROUBLED WARRIOR. A RONIN IS A MASTERLESS SAMURAI, AND OUR CHARACTER'S STANCE SHOWS HE IS A MASTER OF MARTIAL ARTS AND COMBAT. ALL SAMURAI CARRY TWO SWORDS AND SOMETIMES OTHER WEAPONS, TOO.

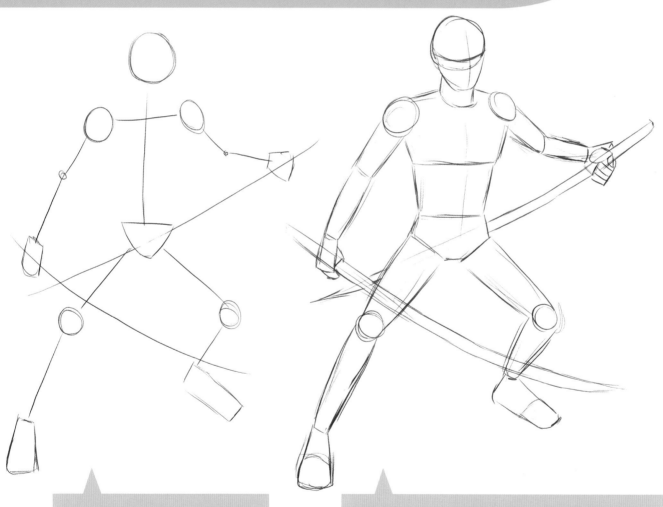

1 Lightly sketch the wireframe, with a guarded stance and two lines for the *katanas*—long, curved Japanese swords.

2 Flesh out his broad chest and limbs—this is no skinny samurai! Make sure his hips are narrower than his shoulders. Pay close attention to the position of his legs and feet.

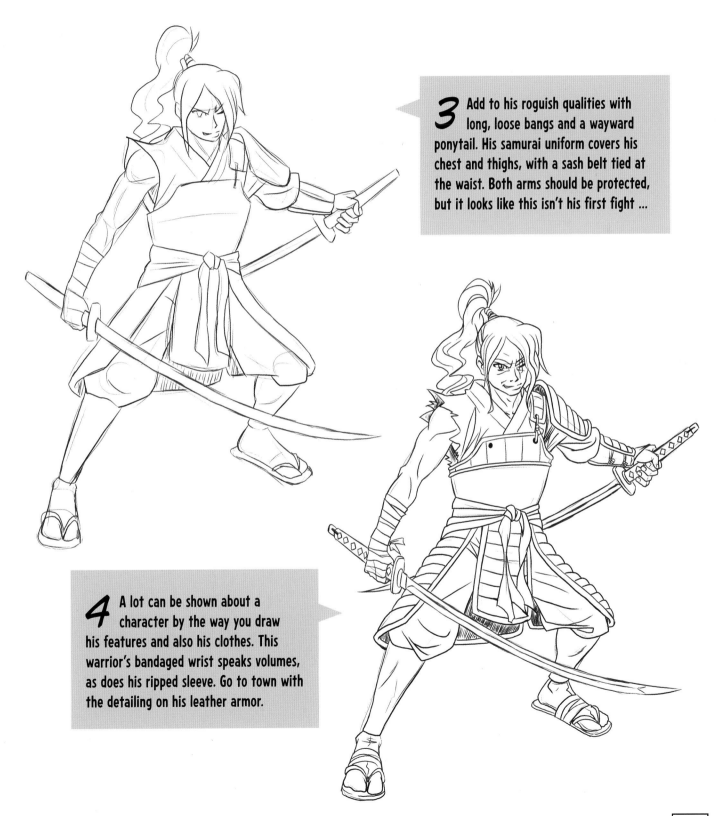

3 Add to his roguish qualities with long, loose bangs and a wayward ponytail. His samurai uniform covers his chest and thighs, with a sash belt tied at the waist. Both arms should be protected, but it looks like this isn't his first fight ...

4 A lot can be shown about a character by the way you draw his features and also his clothes. This warrior's bandaged wrist speaks volumes, as does his ripped sleeve. Go to town with the detailing on his leather armor.

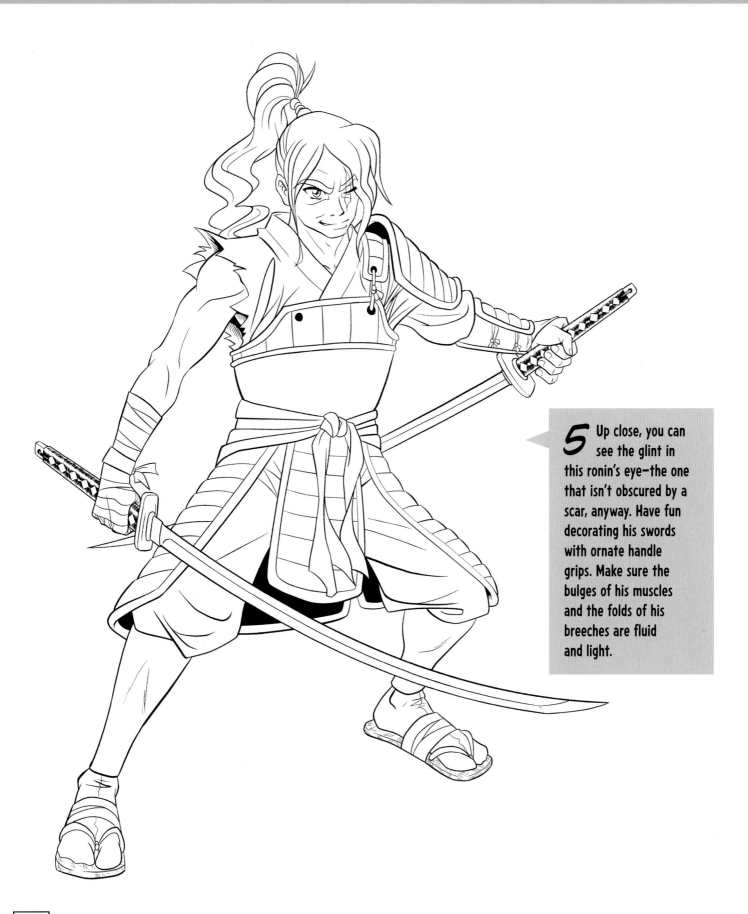

5 Up close, you can see the glint in this ronin's eye—the one that isn't obscured by a scar, anyway. Have fun decorating his swords with ornate handle grips. Make sure the bulges of his muscles and the folds of his breeches are fluid and light.

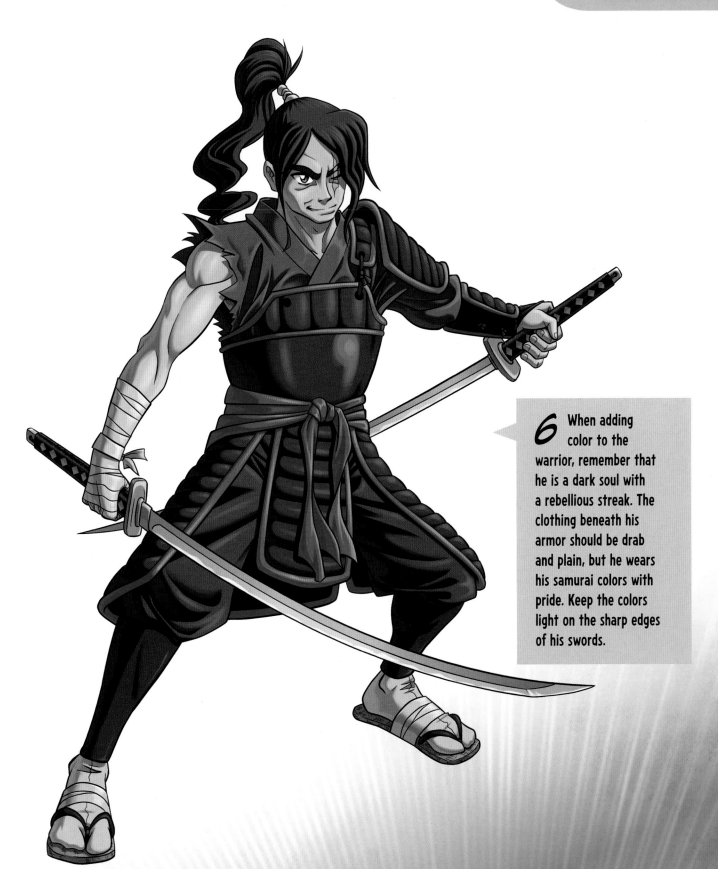

6 When adding color to the warrior, remember that he is a dark soul with a rebellious streak. The clothing beneath his armor should be drab and plain, but he wears his samurai colors with pride. Keep the colors light on the sharp edges of his swords.

SPEED LINES

MANGA CHARACTERS ARE PART OF A STORYTELLING PROCESS WITH ITS OWN TRICKS AND TECHNIQUES. HERE'S HOW A MANGA ARTIST CARRIES THE READER ALONG WITH THE ACTION WHEN THINGS ARE MOVING FAST!

HORIZONTAL SPEED LINES

Neatly ruled parallel lines show the direction of movement. They can be spaced very tightly to show increased speed but tend to be spaced farther apart around elements like the face.

RADIAL SPEED LINES

A starburst of lines spreading from a central point can show rapid movement toward or away from the reader. The blank space where the lines would meet is the far distance.

SPECIAL EFFECTS

PATTERNED MANGA BACKGROUNDS DO THREE THINGS: THEY GRAB THE READER'S ATTENTION, THEY SHOW CHARACTERS' REACTIONS WITHOUT WORDS, AND THEY MAKE FOR AN INTERESTING BREAK FROM STANDARD BACKGROUND SCENERY.

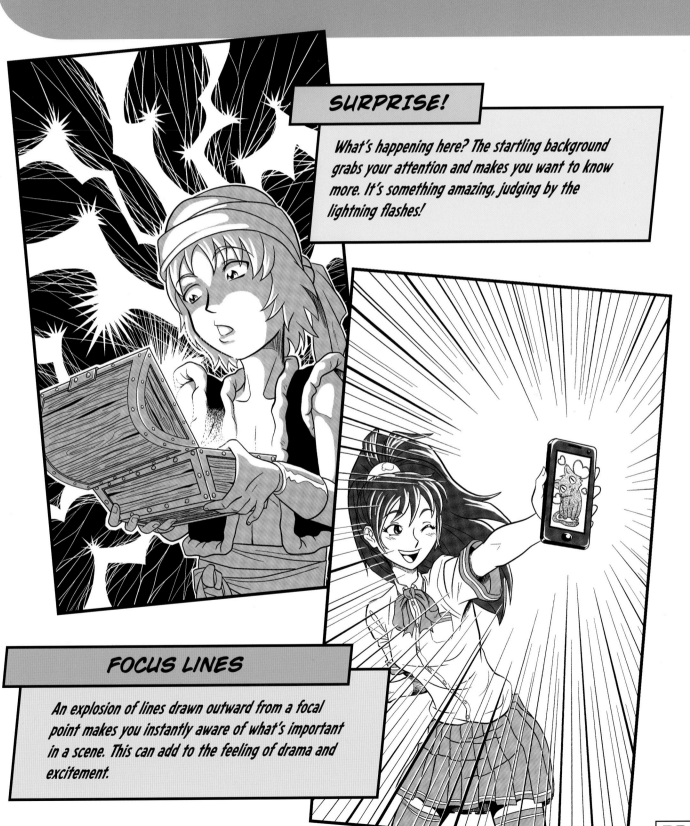

SURPRISE!

What's happening here? The startling background grabs your attention and makes you want to know more. It's something amazing, judging by the lightning flashes!

FOCUS LINES

An explosion of lines drawn outward from a focal point makes you instantly aware of what's important in a scene. This can add to the feeling of drama and excitement.

HOW TO DRAW
A DOJO SCENE

YOU'VE PRACTICED DRAWING CHARACTERS WITH VARIED EXPRESSIONS AND MOVEMENTS, AND ADDING DRAMATIC EFFECTS. NOW IT'S TIME TO PUT ALL THOSE SKILLS TOGETHER TO CREATE AN ACTION-PACKED SCENE IN WHICH SEVERAL CHARACTERS INTERACT WITH EACH OTHER.

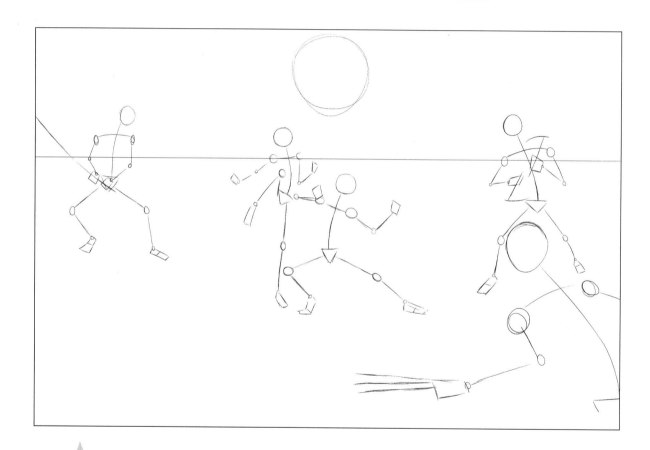

1 Take some time to sketch the position of each character. They should feel like they are interacting in a dramatic way. Where are they each looking? What are they about to do?

2 When you are happy with how the characters fill the frame, sketch in the basic lines of the background. Flesh out each of the characters, making sure they are all in proportion to each other.

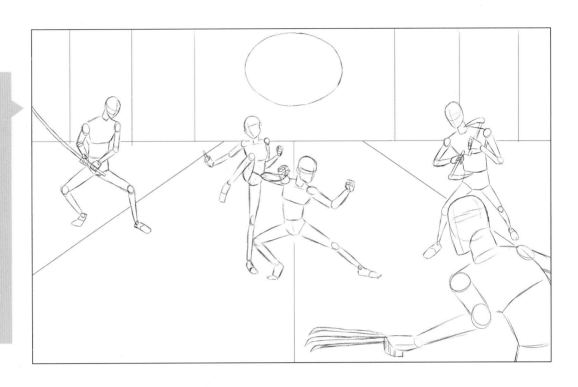

3 Slowly build up the details of the characters and scenery. Don't ruin your hard work by rushing! Ask yourself: Do any areas of the image need more interest? We added some empty robes at the bottom left, to suggest that the ninjas can turn to smoke.

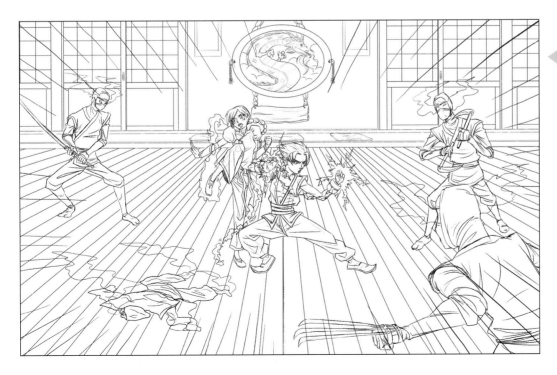

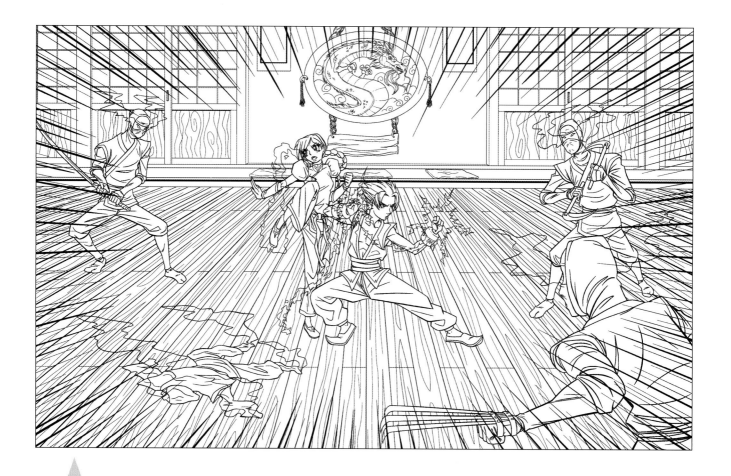

4 As you ink the image, make sure that it's clear what's happening. Who are the good guys and who are the bad guys? Your scene is telling a story, so it's up to you to show what's taking place. Never lose sight of the big picture!

FEARLESS FACES

Remember what you have learned about manga features. Give your heroes big eyes and expressions of brave determination to contrast them with the masked baddies.

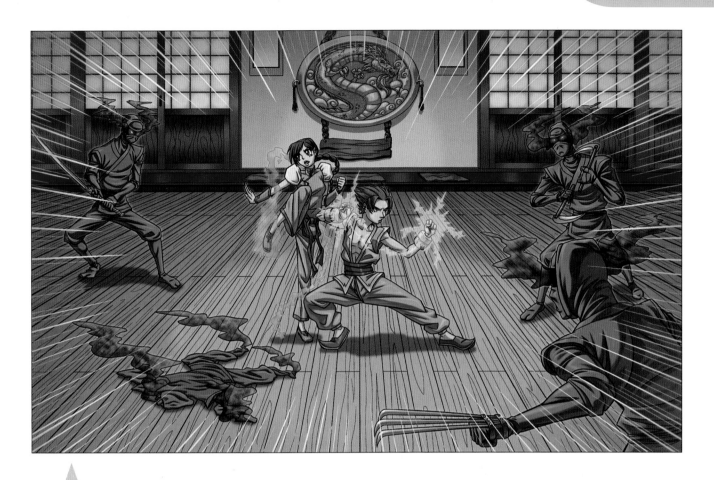

5 Finally, use your coloring to highlight the main characters and make the villains look sinister. Use bold shades in the center, and play with the special effects, adding flames, sparks, and force fields.

GOING FOR GOLD

Bring the decoration to life with white-gold highlights and brown-gold shading.

GLOWING EYES

Leave the middle of the ninjas' eyes bright white, but color the area around them red.

SUPERHERO COMICS

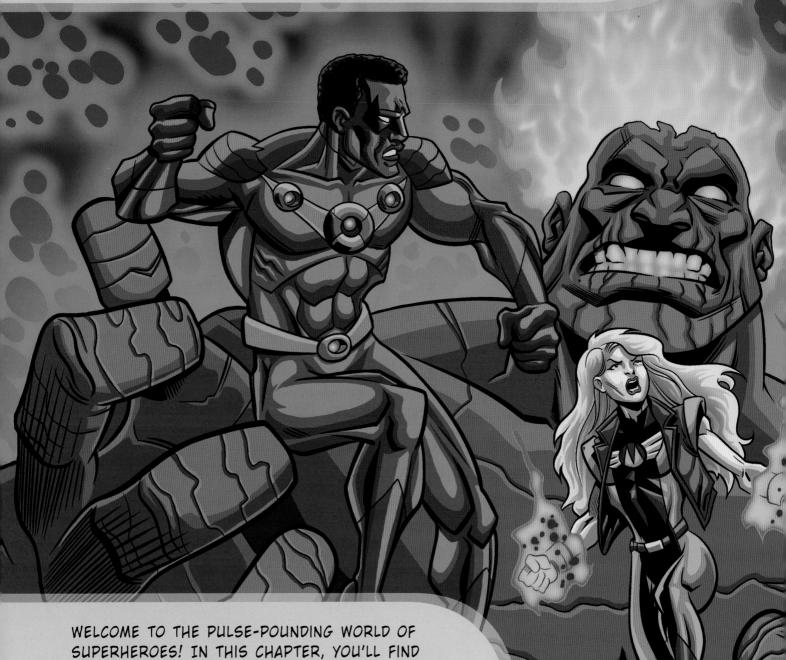

WELCOME TO THE PULSE-POUNDING WORLD OF SUPERHEROES! IN THIS CHAPTER, YOU'LL FIND STEP-BY-STEP GUIDES SHOWING YOU HOW TO DRAW SOME HEROES WE'VE CREATED SPECIALLY FOR THIS BOOK. WE'LL ALSO GIVE YOU THE TOOLS TO CREATE NEW CHARACTERS OF YOUR OWN!

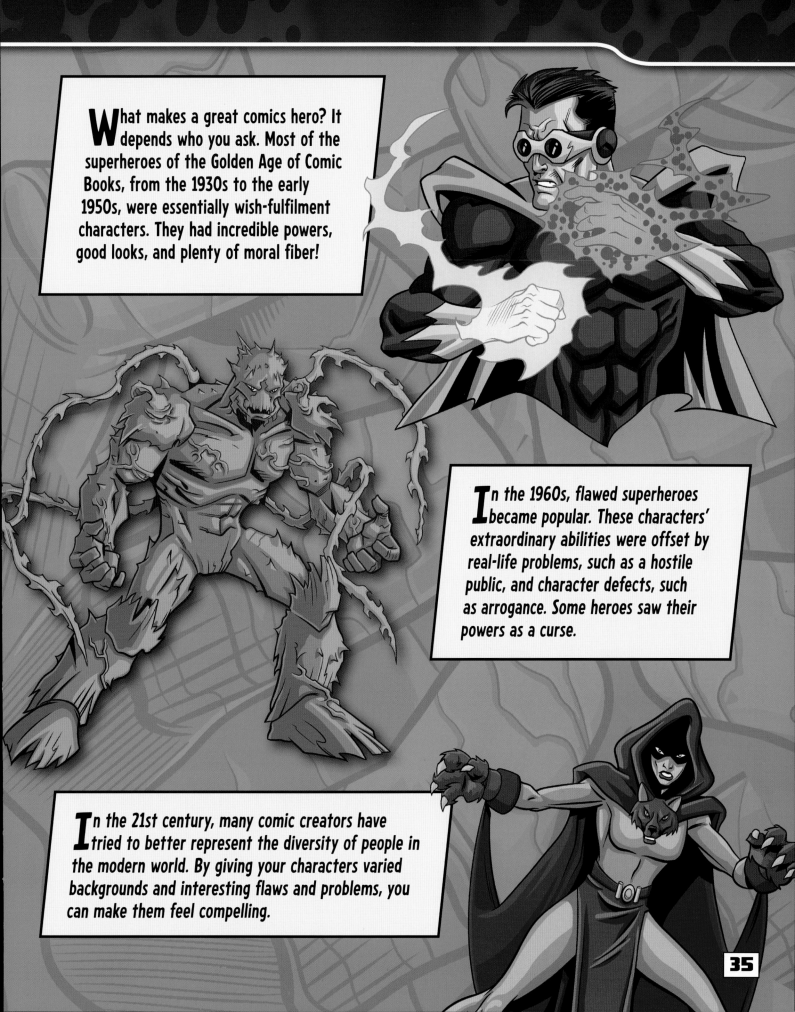

What makes a great comics hero? It depends who you ask. Most of the superheroes of the Golden Age of Comic Books, from the 1930s to the early 1950s, were essentially wish-fulfilment characters. They had incredible powers, good looks, and plenty of moral fiber!

In the 1960s, flawed superheroes became popular. These characters' extraordinary abilities were offset by real-life problems, such as a hostile public, and character defects, such as arrogance. Some heroes saw their powers as a curse.

In the 21st century, many comic creators have tried to better represent the diversity of people in the modern world. By giving your characters varied backgrounds and interesting flaws and problems, you can make them feel compelling.

G-FORCE
MASTER OF GRAVITY

ARE YOU READY TO DRAW YOUR FIRST SUPERHERO? ROCKET SCIENTIST TODD TRAVIS WAS BUILDING THE WARP DRIVE OF AN EXPERIMENTAL SHIP WHEN THE ENGINE EXPLODED. THE COSMIC ENERGY GAVE HIM THE ABILITY TO CONTROL GRAVITY. NOW HE FIGHTS CRIME ACROSS THE GALAXY!

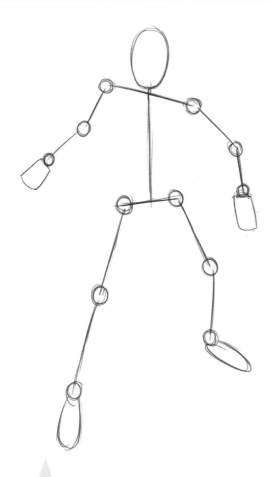

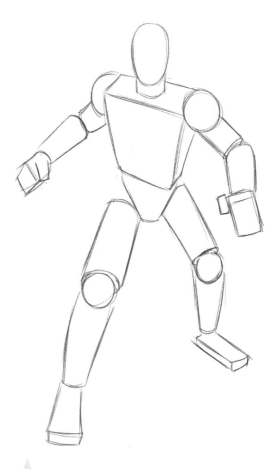

1 It's important that you get the initial pose and proportions right. Sketch a wireframe showing limbs and joints.

2 Use basic shapes to build on top of your wireframe. His hips are triangular, and his chest tapers to the waist. The leg that is closest to us looks slightly longer than the trailing leg.

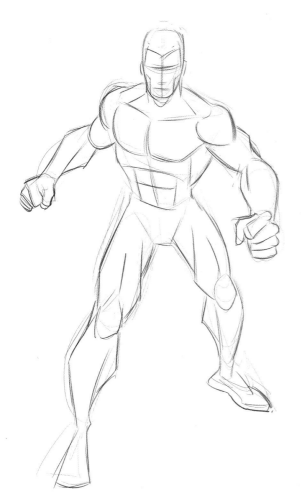

3 Now you can bulk up the body and outline where the features will go. Sketch in G-Force's leg and arm muscles, and define those in his stomach area. Round off the joints and add details to the hands and feet, including fingers and knuckles.

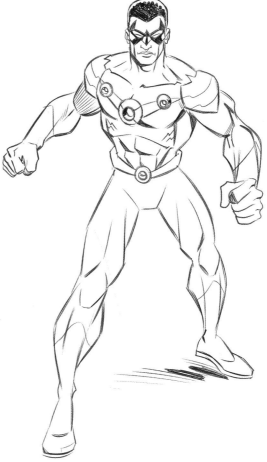

4 It's costume time! What is your newly invented character going to look like? G-Force has some high-tech nodes across his chest and on his belt, which help him keep control of his gravity powers. His identity is hidden by a domino mask.

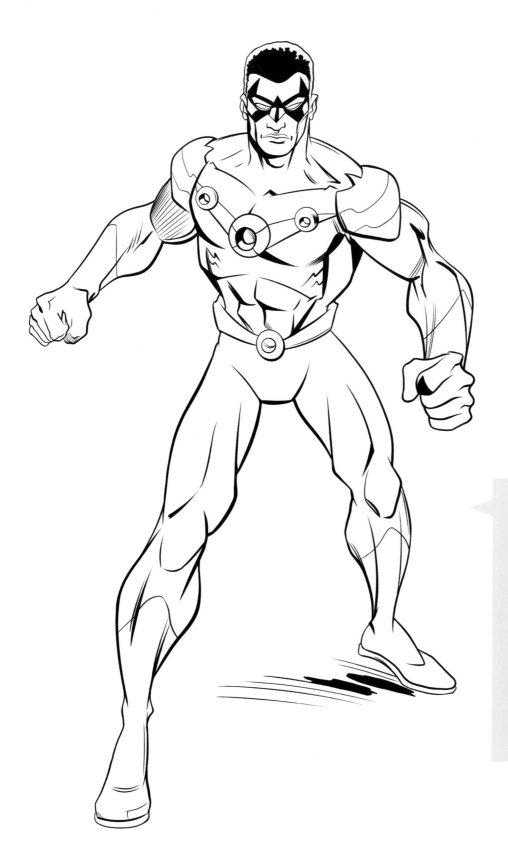

5 The inking stage is your opportunity to choose the strongest lines in your illustration and bring them out with nice, sharp line work. Keep your hand steady as you outline all those muscles. This cosmic hero is bulked-up and brainy, so bad guys had better beware!

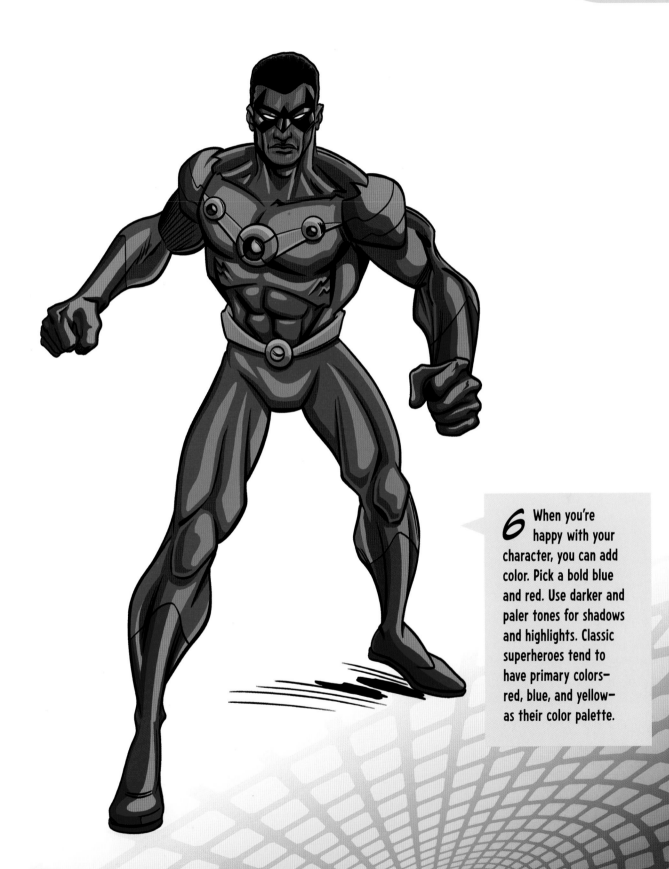

6 When you're happy with your character, you can add color. Pick a bold blue and red. Use darker and paler tones for shadows and highlights. Classic superheroes tend to have primary colors—red, blue, and yellow—as their color palette.

STYLES OF COMIC ART

THERE'S MORE THAN ONE WAY TO DRAW A COMIC CHARACTER!
DOC TWILIGHT HAS THE ABILITY TO CONTROL LIGHT AND DARKNESS ...
AND HERE WE'VE DRAWN HIM WITH FOUR DIFFERENT APPROACHES.

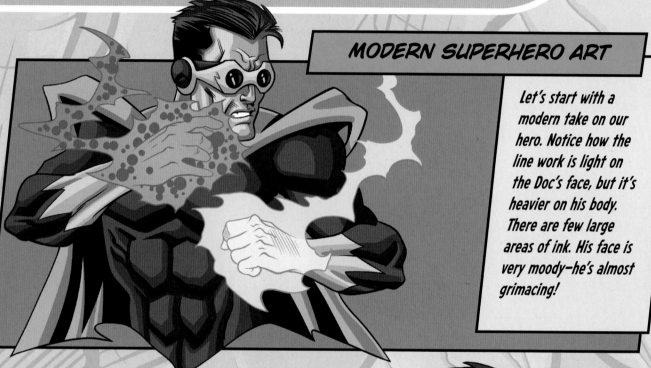

MODERN SUPERHERO ART

Let's start with a modern take on our hero. Notice how the line work is light on the Doc's face, but it's heavier on his body. There are few large areas of ink. His face is very moody—he's almost grimacing!

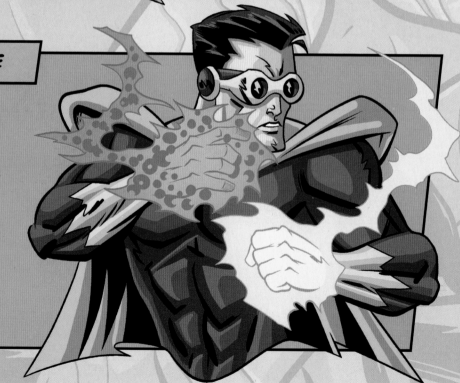

ALL-ACTION STYLE

This "retro" art style harks back to the energetic line work of famous comic artist Jack Kirby. The lines on Doc Twilight's face and body are more angular—many of them are shaped like zigzags.

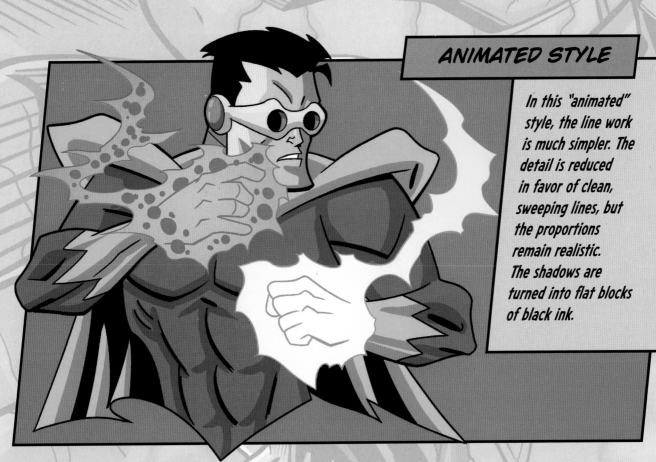

ANIMATED STYLE

In this "animated" style, the line work is much simpler. The detail is reduced in favor of clean, sweeping lines, but the proportions remain realistic. The shadows are turned into flat blocks of black ink.

NOIR STYLE

Noir is the French word for black. It's a style of artwork that tends to be used for stories about crime or the supernatural. It has large areas of shadow in place of fine details, with a strong contrast between colors.

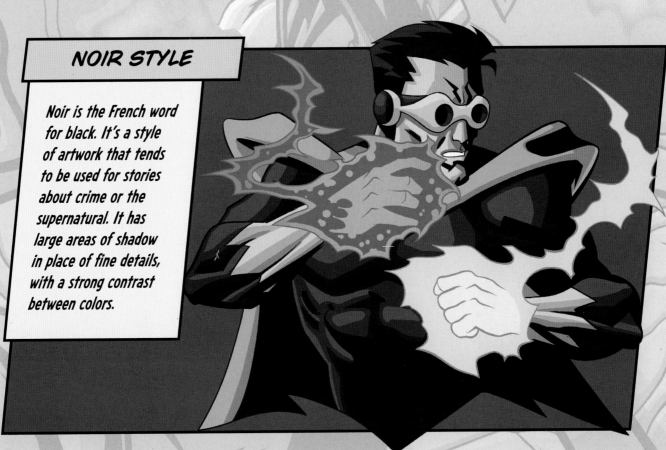

VICTORY
THE ULTIMATE SOLDIER

LET'S CREATE ANOTHER SUPERHERO. SECRET MILITARY EXPERIMENTS HAVE TRANSFORMED FORMER MARINE VIKKI VENTURA—A.K.A. VICTORY—INTO A HUMAN FIGHTER PLANE. SHE CAN FLY AT SUPERSONIC SPEEDS AND FIRE BLASTS OF ENERGY FROM HER FINGERTIPS.

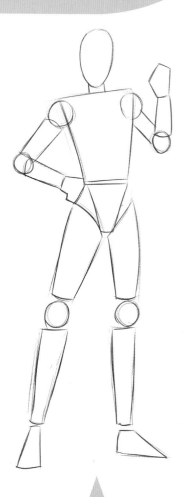

1 Sketch the wireframe with a line for the shoulders and slightly narrower hips. Her raised hand is her weapon.

2 Add the simple shapes that make up her body and limbs. Avoid using straight lines when you are drawing people. Slight curves give them more movement and poise.

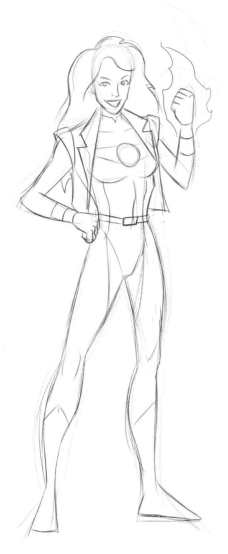

3 Begin to add the details of her hair and face. Sketch your rough ideas for her costume, including wrist cuffs, belt, and boots. Add an outline of the power that she shoots from her clenched fist.

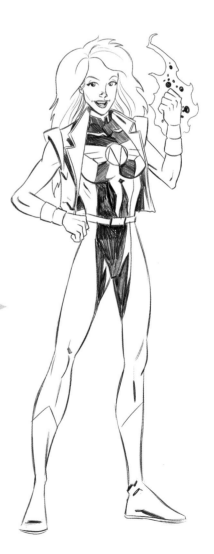

4 Use shading to define Victory's costume, including her short, armless jacket. Like many superheroes, her costume is tight-fitting and practical. Pay attention to the details of her winged chest symbol.

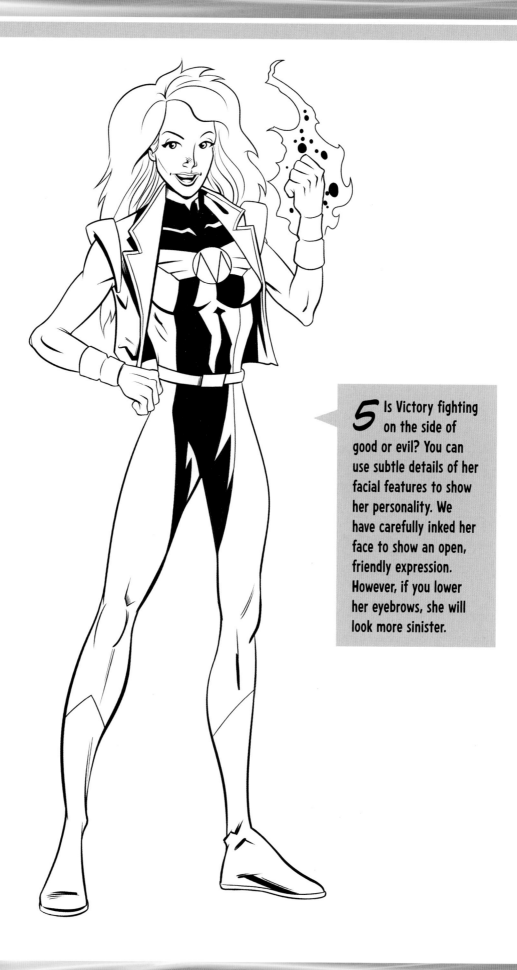

5 Is Victory fighting on the side of good or evil? You can use subtle details of her facial features to show her personality. We have carefully inked her face to show an open, friendly expression. However, if you lower her eyebrows, she will look more sinister.

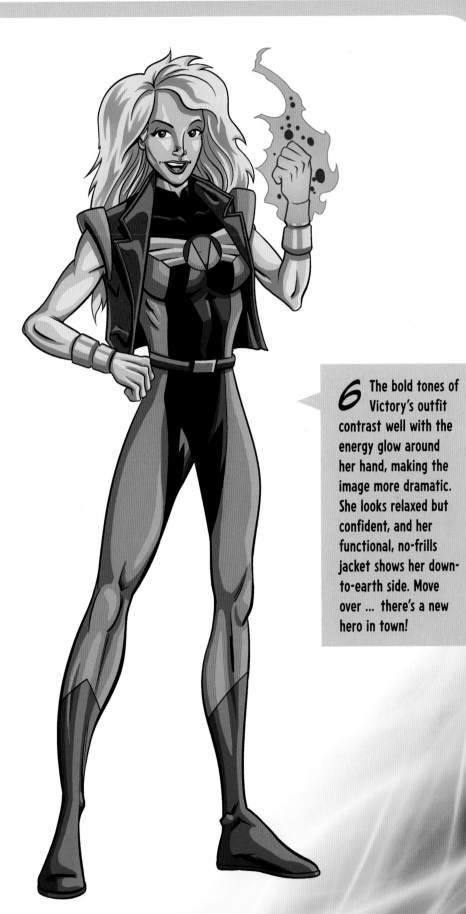

6 The bold tones of Victory's outfit contrast well with the energy glow around her hand, making the image more dramatic. She looks relaxed but confident, and her functional, no-frills jacket shows her down-to-earth side. Move over ... there's a new hero in town!

CREATING NEW CHARACTERS

IF YOU'RE CREATING YOUR OWN SUPERHERO COMIC, YOU MIGHT WANT TO USE YOUR OWN SUPERHEROES OR SUPERVILLAINS. WHERE CAN YOU FIND INSPIRATION FOR NEW CHARACTERS?

ANIMAL HEROES

One way to devise a new character is to take inspiration from an animal. Many superheroes, such as Batman and Spider-Man, have the characteristics and capabilities of animals.

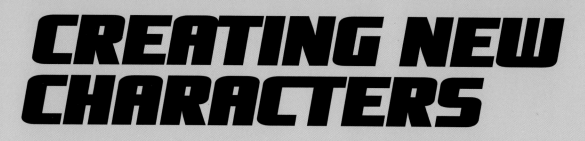

Magpie is an excellent thief. Like real magpies, she has a love of shiny things—such as priceless jewels!

NATURE HEROES

You can take your starting point from other aspects of nature, such as clouds, rainbows, volcanoes, or plants.

Tanglevine's body is covered in tough, thorny armor. He can use the vines sprouting from his back to entangle his enemies.

STORYBOOK HEROES

Some comic characters are inspired by other fictional characters, such as the mythical god Thor or Robin Hood.

This savage superhero, the Scarlet Hood, is inspired by the story of Red Riding Hood. Like the heroine of that story, she wears a long red cloak. She also has the claws of a big, bad wolf!

SCIENCE HEROES

Science, whether real or science fiction, provides excellent inspiration for comic book superpowers.

The Hologram is a robotic superhero inspired by real-life holograms and lasers. He can shoot light beams from his hands and create illusions.

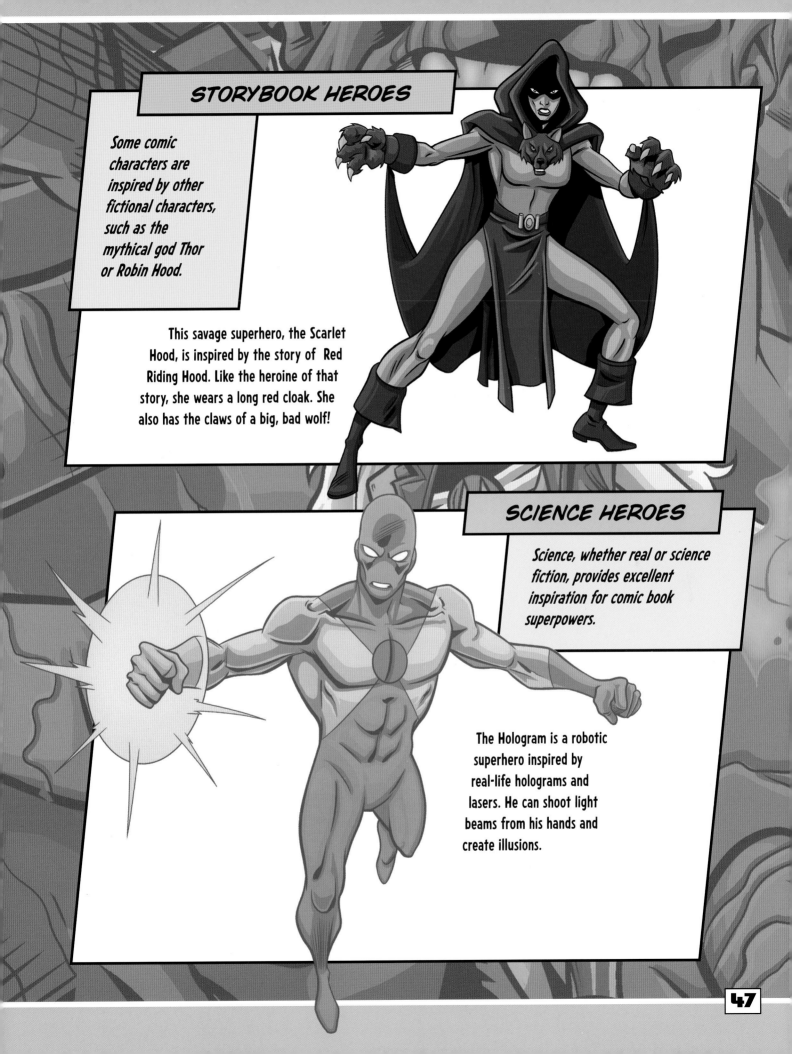

THE VULCANOID
FEARSOME FORCE OF NATURE

IT'S TIME TO UNLEASH A SUPERVILLAIN! THE VULCANOID IS INSPIRED BY REAL-LIFE VOLCANOES. HE HAS A ROCKY HIDE AND CAN SHOOT DEADLY BLASTS OF MOLTEN LAVA. HE HAS A HEAVY, BULKY "BRUISER" BUILD AND AN UNUSUAL, ROCKY SKIN TEXTURE.

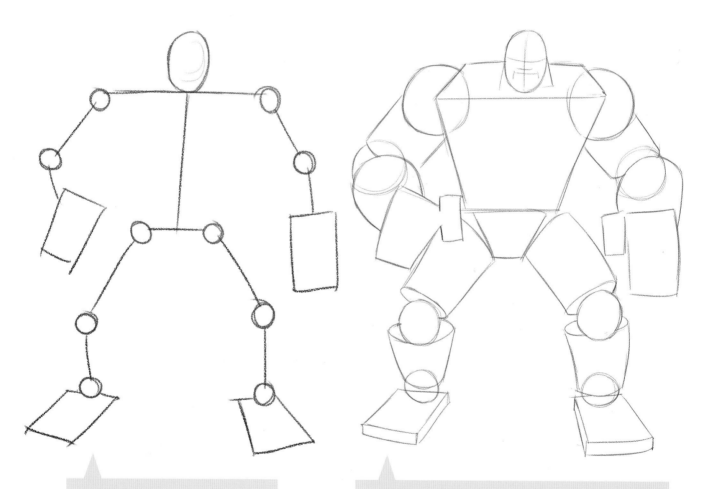

1 Start with an oversized wireframe. Make its head small, but exaggerate the size of its feet and hands.

2 Build on the frame using basic shapes. Begin to fill out the figure, building it up around the shoulders, forearms, and lower legs. Its upper torso should be broad, narrowing at the waist.

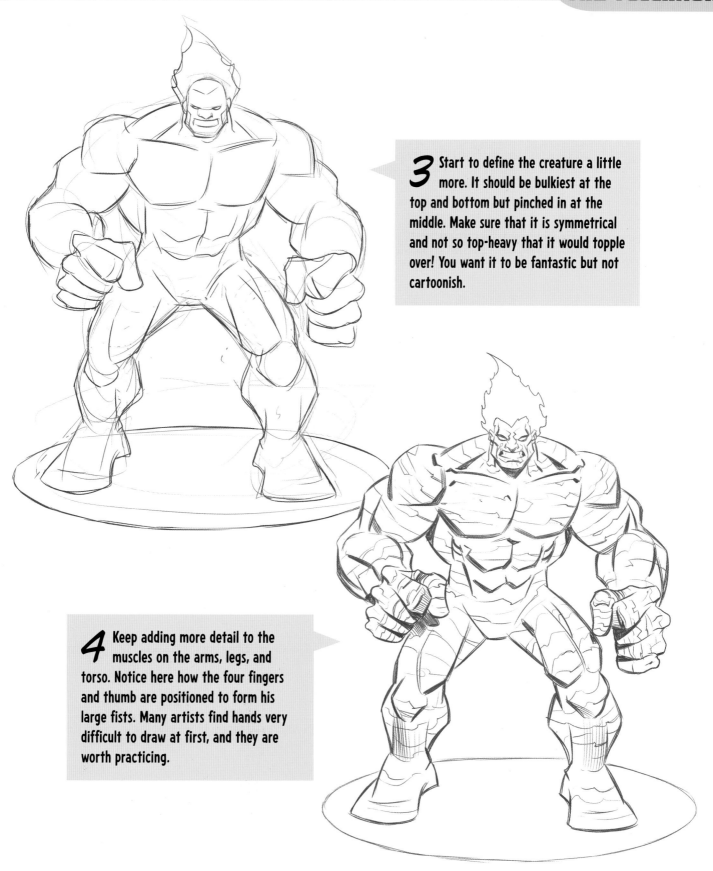

3 Start to define the creature a little more. It should be bulkiest at the top and bottom but pinched in at the middle. Make sure that it is symmetrical and not so top-heavy that it would topple over! You want it to be fantastic but not cartoonish.

4 Keep adding more detail to the muscles on the arms, legs, and torso. Notice here how the four fingers and thumb are positioned to form his large fists. Many artists find hands very difficult to draw at first, and they are worth practicing.

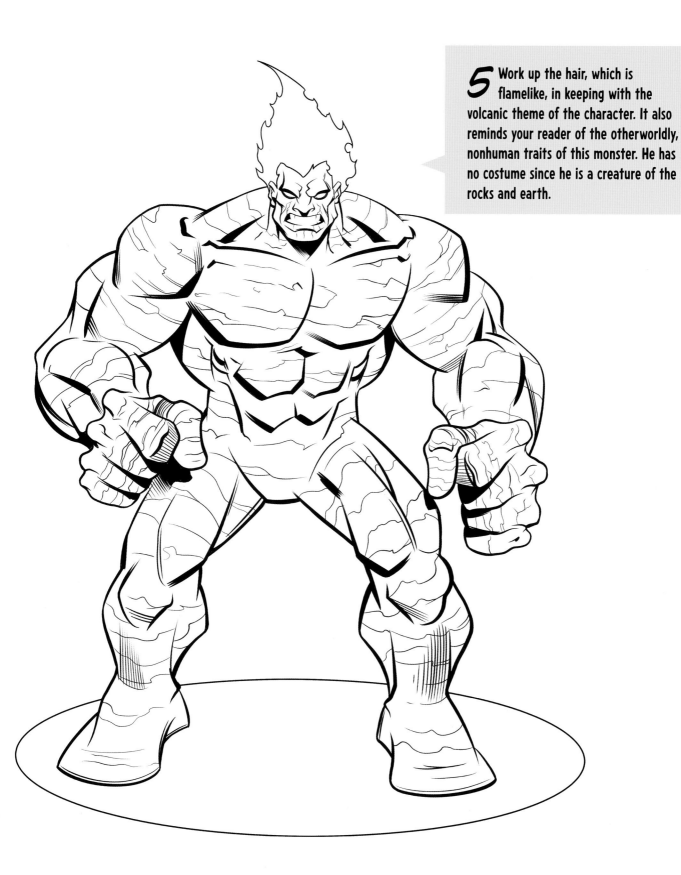

5 Work up the hair, which is flamelike, in keeping with the volcanic theme of the character. It also reminds your reader of the otherworldly, nonhuman traits of this monster. He has no costume since he is a creature of the rocks and earth.

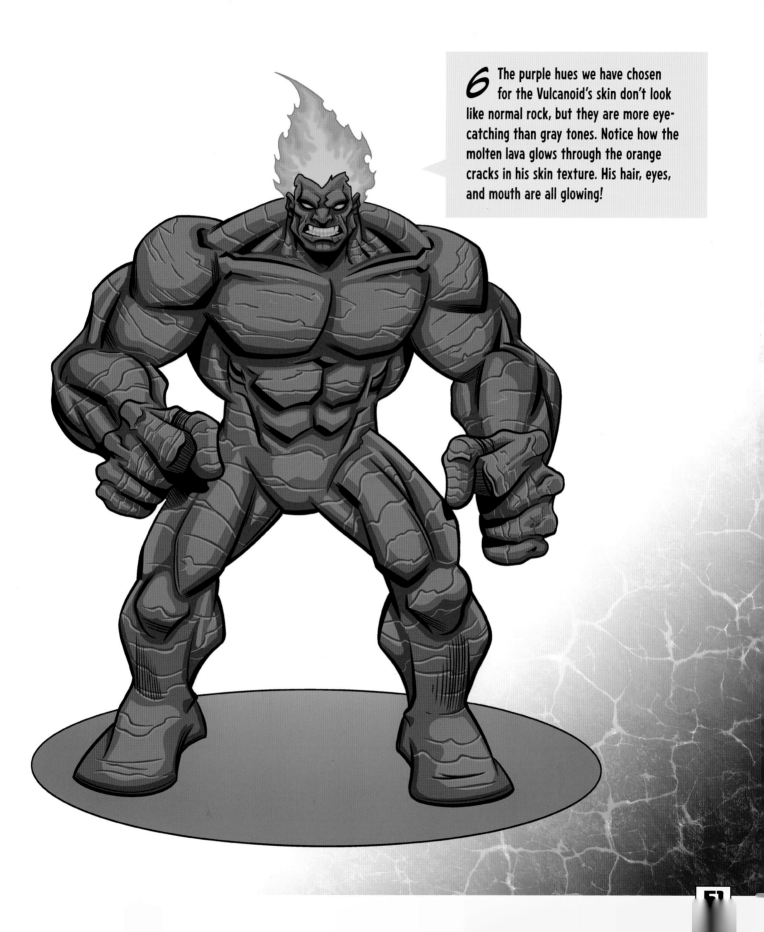

6 The purple hues we have chosen for the Vulcanoid's skin don't look like normal rock, but they are more eye-catching than gray tones. Notice how the molten lava glows through the orange cracks in his skin texture. His hair, eyes, and mouth are all glowing!

ACTION POSES: RUNNING

IN SUPERHERO COMICS, CHARACTERS' MOVEMENTS TEND TO BE LARGER THAN LIFE. READERS WANT TO SEE THEIR HEROES IN CONSTANT ACTION! ARTISTS USE VARIOUS TRICKS TO TAKE A REALISTIC MOVEMENT AND EXAGGERATE IT TO INCREASE ITS VISUAL IMPACT.

REALISTIC RUNNING

When captured in a drawing, realistic running can look surprisingly slow and stately. The limbs of an actual runner swing only so much, and the body is fairly upright.

DYNAMIC RUNNING

In this dynamic image, the character's arms and legs are flung forward and backward, with the body at an extreme angle. The leading hand is very near to us, and the trailing foot seems far away.

ACTION POSES: THROWING A PUNCH

IT WOULD BE RARE FOR A SUPERHERO TO SAVE THE DAY WITHOUT GETTING INTO SOME SORT OF A FIGHT. WHETHER YOU'RE DRAWING A SMALL-SCALE SKIRMISH IN A DARK ALLEY OR A SUPERHUMAN-STRENGTH PUNCH ROCKETING AN ENEMY INTO ORBIT, THE SAME PRINCIPLES APPLY.

REALISTIC PUNCH

A real boxer would be balanced when he throws a punch, keeping his body upright and his feet grounded for maximum stability. But that doesn't look so exciting when you draw it ...

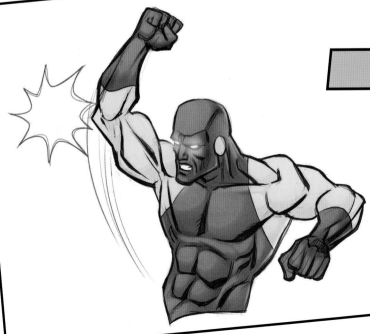

DYNAMIC PUNCH

Instead, a superhero artist relaxes that approach and shifts the body and arms. The punching arm is almost fully extended, while the rear arm is less defensive. Motion lines show power and speed.

AN ACTION SCENE

ONCE YOU HAVE PRACTICED DRAWING YOUR CHARACTERS INDIVIDUALLY IN VARIOUS POSES, TRY PITTING THEM AGAINST EACH OTHER IN A DYNAMIC "SPLASH" PANEL. FOLLOW EACH STEP CAREFULLY, AND THE FINAL IMAGE WILL COME TOGETHER PERFECTLY!

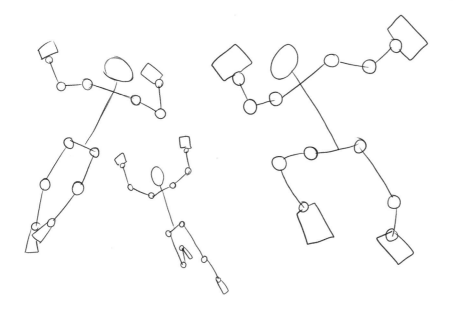

1 Here, three characters are caught up in an aerial battle. The largest character is the hefty Vulcanoid. Victory is smaller than G-Force, because she is farther away from the viewer.

2 The outstretched arms of each of the combatants shows they are balanced and poised, either on the floating platform or in midair, ready to strike. Lightly sketch in the buildings behind them, making sure they look three-dimensional and to scale.

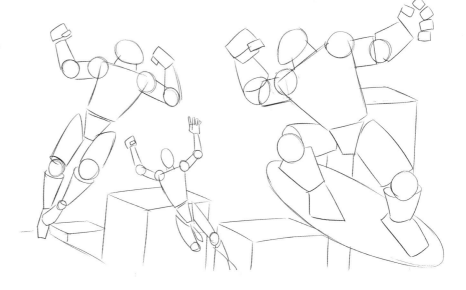

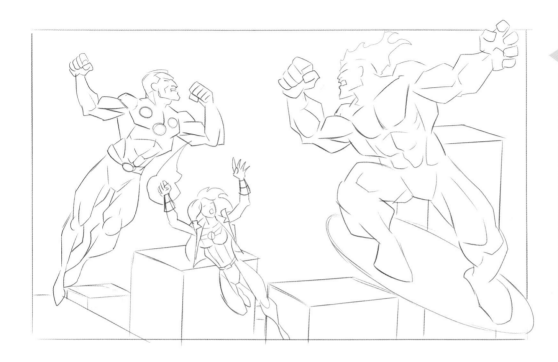

3 Now flesh out each of your characters. Plan the basic positioning of facial features, and sketch in their muscles and costume elements. Where is each character looking? What are they about to do?

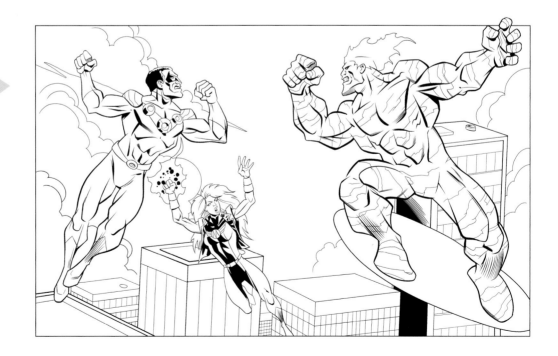

4 As you ink the image, pay special attention to your characters' faces. Use a ruler to add details to the buildings. Work in some blocks of shading on G-Force's hair, Victory's costume, and the building behind the Vulcanoid.

You might want to practice your coloring in a rough sketch. A mistake on your final artwork could ruin an awful lot of hard work! Keep the background colors light and simple, so that the action leaps off the page.

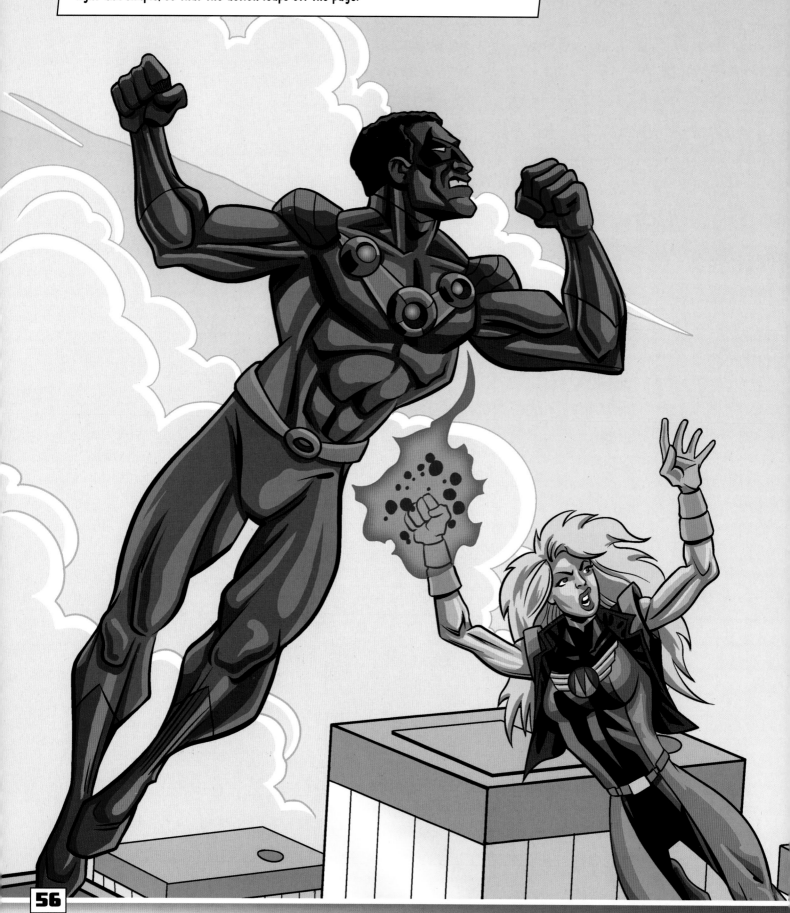

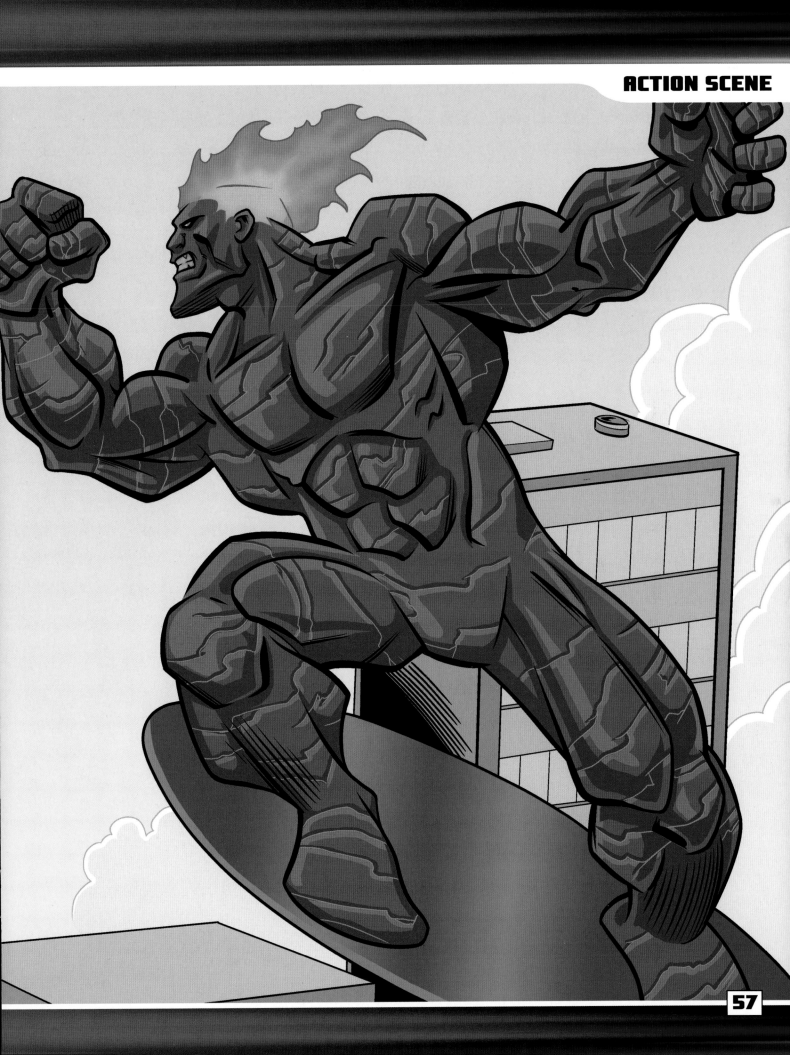

SCIENCE FICTION COMICS

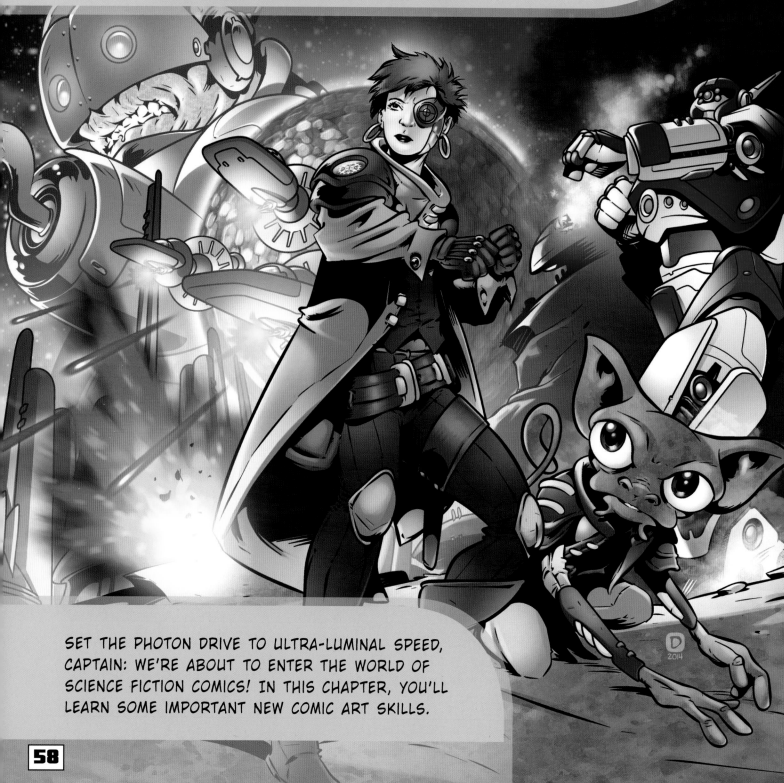

SET THE PHOTON DRIVE TO ULTRA-LUMINAL SPEED, CAPTAIN: WE'RE ABOUT TO ENTER THE WORLD OF SCIENCE FICTION COMICS! IN THIS CHAPTER, YOU'LL LEARN SOME IMPORTANT NEW COMIC ART SKILLS.

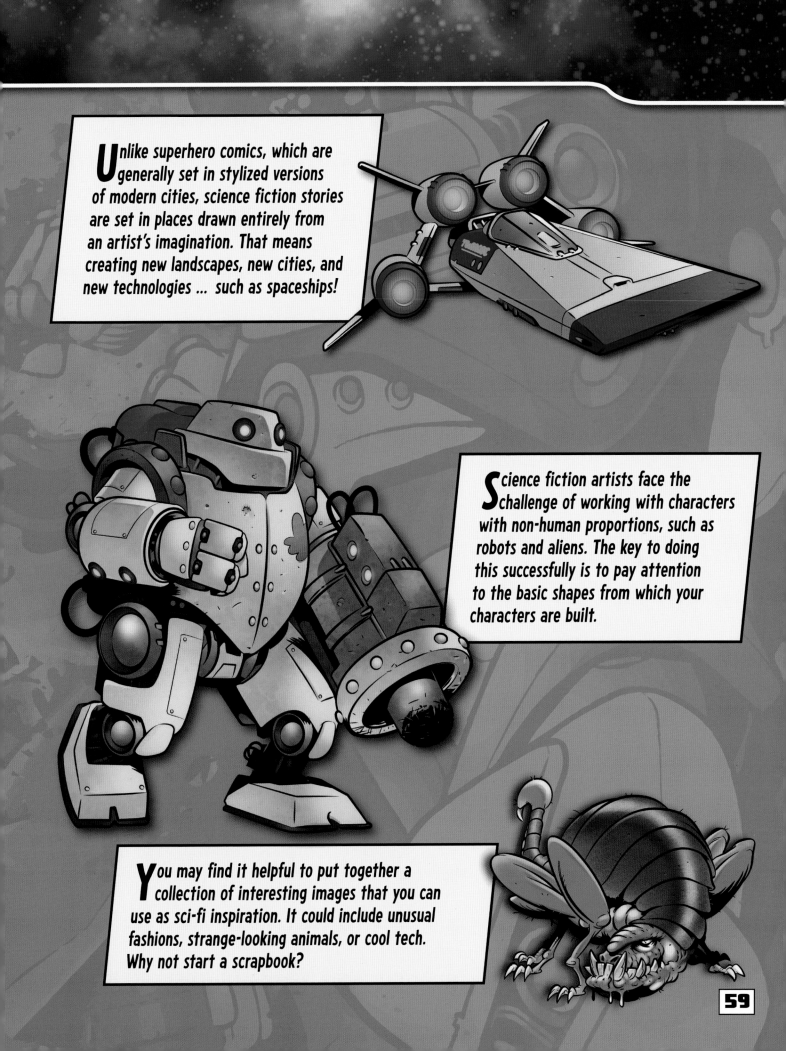

Unlike superhero comics, which are generally set in stylized versions of modern cities, science fiction stories are set in places drawn entirely from an artist's imagination. That means creating new landscapes, new cities, and new technologies ... such as spaceships!

Science fiction artists face the challenge of working with characters with non-human proportions, such as robots and aliens. The key to doing this successfully is to pay attention to the basic shapes from which your characters are built.

You may find it helpful to put together a collection of interesting images that you can use as sci-fi inspiration. It could include unusual fashions, strange-looking animals, or cool tech. Why not start a scrapbook?

A SPACE PIRATE

CAPTAIN XARA QUINN USED TO WORK FOR THE INTERGALACTIC POLICE, BUT SHE BECAME ANGRY WITH THE CORRUPTION SHE SAW. NOW SHE'S GOING IT ALONE AND KNOWS THERE'S NO SUCH THING AS GOOD GUYS AND BAD GUYS: IT'S EVERY WOMAN FOR HERSELF!

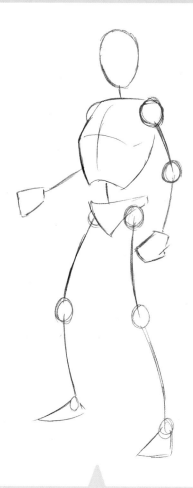

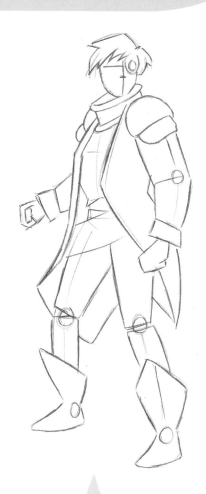

1 First, you should sketch a wireframe showing how you want Xara to stand. Get the proportions right at this stage.

2 Flesh out the wireframe with the basic shapes for legs and arms. Add the outline of Xara's military coat and boots. Sketch a cross on her face to get the features in the right place.

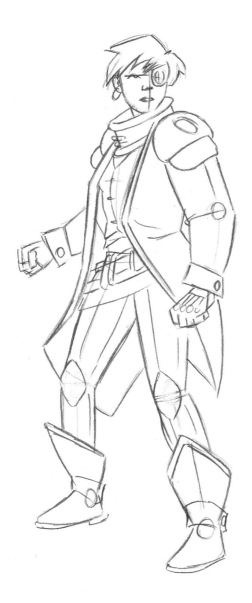

3 In true pirate fashion. Xara has an eyepatch—but hers is a futuristic, cybernetic scanner. Sketch her short, funky hair. Add armored shoulder and knee pads and studded gloves. Her hoop earrings are another nod to old-world pirates.

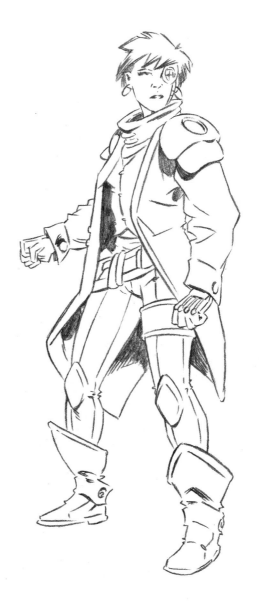

4 Work up the details of her outfit, such as her utility belt and thigh cuff. Add shadows underneath her coat. A few delicate lines here and there show the folds of her clothes and boots. Finish the features of her face, keeping her tough but feminine.

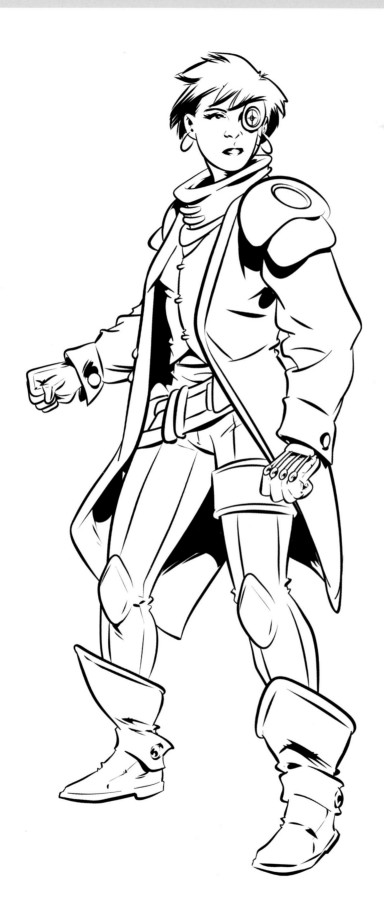

5 Now you can begin to go over your final lines with ink. Erase any guide lines that are still visible. Use a fine pen so that you can draw small details, such as her gloves and buttons. She's a funky, punky pirate, and she's ready for action!

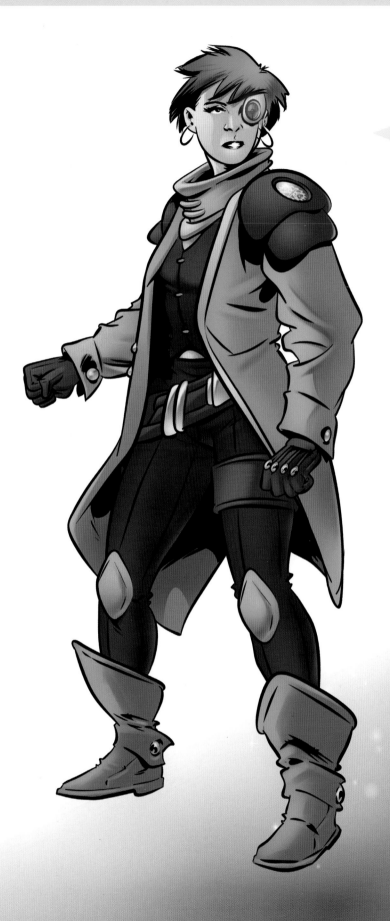

6 Think carefully about your color scheme. Xara's coat and boots are reminiscent of traditional pirates, but her green spiky hair feels modern or even futuristic. Notice how the shading on her coat uses darker tones of the basic colors.

DRAWING ALIEN CHARACTERS

SCIENCE FICTION IS AN IMAGINATIVE GENRE. YOU WILL NEED TO BE ABLE TO DRAW CREATURES THAT LOOK VERY DIFFERENT FROM THOSE WE MIGHT FIND ON EARTH. WHAT WILL BE YOUR INSPIRATION?

HUMANOID ALIENS

When you draw a wireframe for a humanoid alien character, consider tweaking and changing the proportions of a normal human. Give them extra limbs, or change the way that their joints work.

SIX EXTRA-LONG ARMS

MULTIPLE EYES LIKE A SPIDER

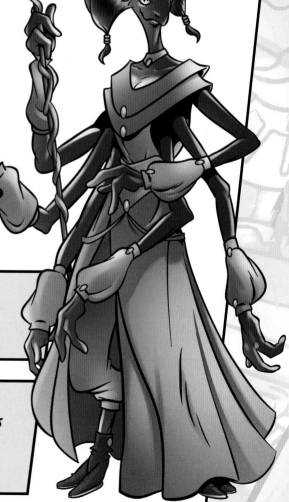

LEGS WITH TWO KNEE JOINTS

CLOTHING LOOSELY INSPIRED BY THE ANCIENT MIDDLE EAST

As you flesh out the character, think about how the details of their face and body might use features taken from animals here on Earth.

You can find inspiration in clothing from different historical periods or parts of the world. Make sure that your character looks the part for their station in life. This creature is an alien queen.

MONSTROUS ALIENS

When creating an alien monster, it is a good idea to use a combination of Earth creatures as a starting point. This character uses aspects of several creatures, including a woodlouse and a crocodile.

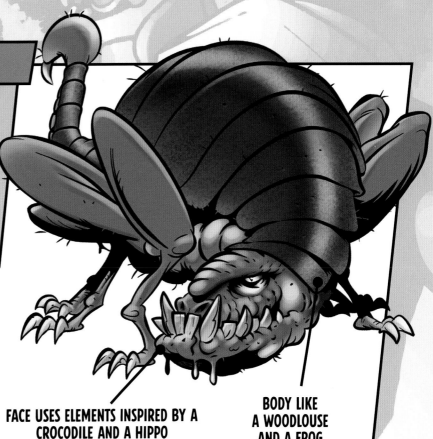

FACE USES ELEMENTS INSPIRED BY A CROCODILE AND A HIPPO

BODY LIKE A WOODLOUSE AND A FROG

CUTE CRITTERS

If you want a creature to act like an appealing and lovable companion, you will need to follow certain rules. Large heads, big eyes, and rounded body shapes make for cute creatures. Just about everything else is up to you.

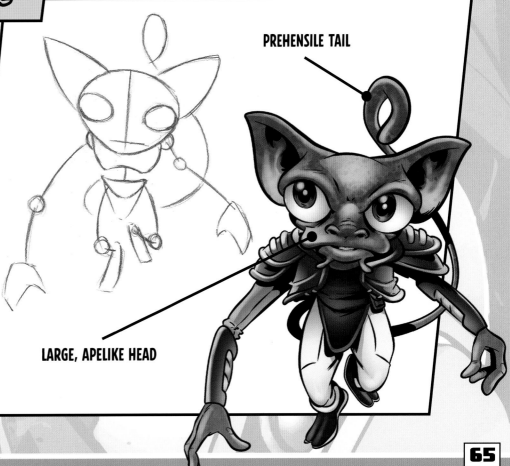

PREHENSILE TAIL

LARGE, APELIKE HEAD

AN ALIEN BIKER

IT MAY LOOK LIKE SOMEONE HAS STOLEN THIS ALIEN BIKER'S WHEELS, BUT THAT'S NO ORDINARY BIKE HE'S RIDING. IT'S A HOVERBIKE! VRILAK SKREE IS THE LEADER OF A FAMOUS SPACE GANG. NO ONE WOULD BE FOOLISH ENOUGH TO STEAL FROM HIM.

1 Loosely sketch the circles needed for his head, body, and joints. Give Vrilak elongated arms and legs.

2 When you're happy with his seated position, add the basic shape of his bike. Play around with different shapes to see what looks best. Build up the outline of his limbs and clothes.

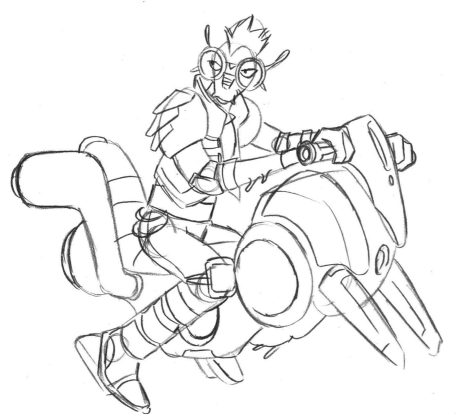

3 Let your imagination run wild when you fill in the details on his bike and outfit. When creating science fiction vehicles, it's a good idea to look at real, present-day vehicles for inspiration. Use the elements that you think look cool.

4 Think about where the light is coming from and how it will cast shadows. Lit from above, the underside of the bike will be in darkness, with shaded areas where Vrilak's body blocks the light, too. Keep adding more textural details to his outfit. He loves all kinds of studs, chains, and metal plates!

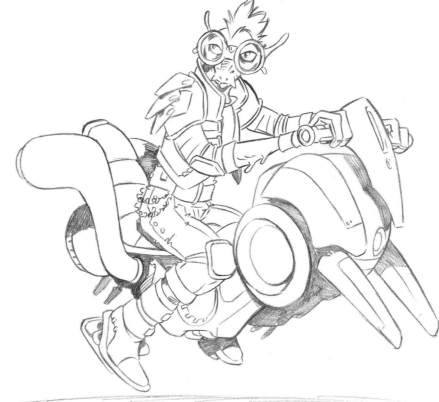

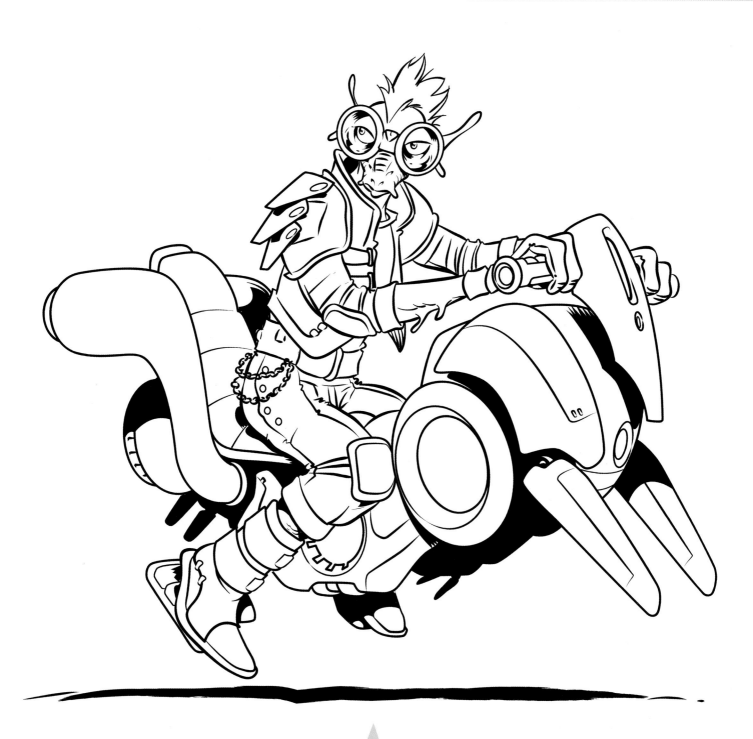

5 Take your time at the inking stage. You don't want to ruin your hard work now that you've come this far. You'll need a steady hand for the curves and circles. Keep the lines on the bike to a minimum, so that Vrilak is still the main focus of attention in the image.

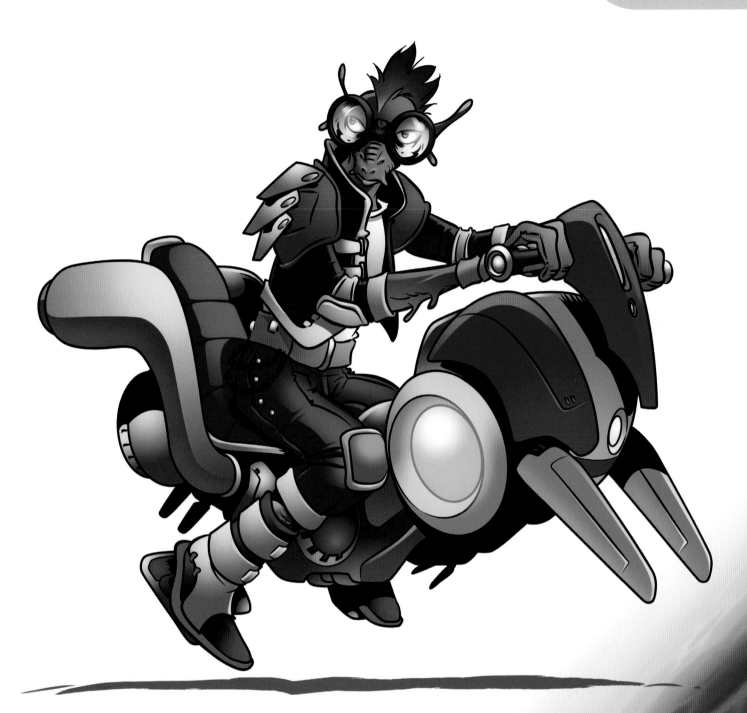

6 You can have fun choosing strange colors for your alien creatures. Vrilak has green skin like a reptile. The silver and red details of his armor stand out nicely against his black jacket and blue pants. His mohican and his shoulder guards match the bodywork of the bike. What a show-off!

DRAWING ROBOTS

DRAWING ROBOTS CAN BE DAUNTING. THE IMPORTANT THING TO REMEMBER IS THAT THEY START WITH SIMPLE SHAPES, JUST LIKE DRAWINGS OF PEOPLE. GET THE INITIAL SHAPES RIGHT, AND YOU WILL HAVE A FINISHED ROBOT THAT LOOKS FANTASTIC!

HUMANOID ROBOT

BASIC SHAPES

This demolition droid is made up of flattened disks, tubes, cuboids, and egg shapes.

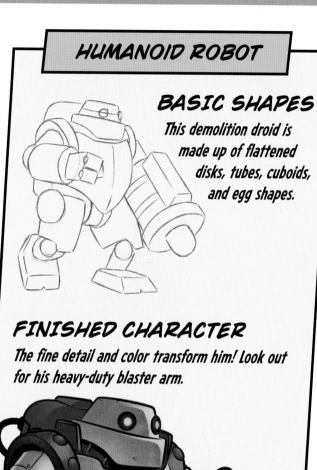

FINISHED CHARACTER

The fine detail and color transform him! Look out for his heavy-duty blaster arm.

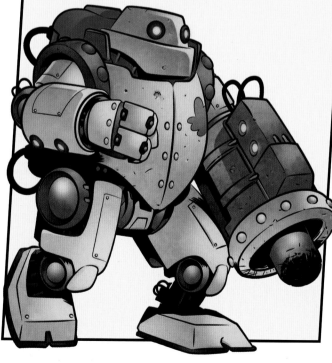

NONHUMANOID ROBOT

BASIC SHAPES

This medical droid is not based on any familiar human or animal shapes.

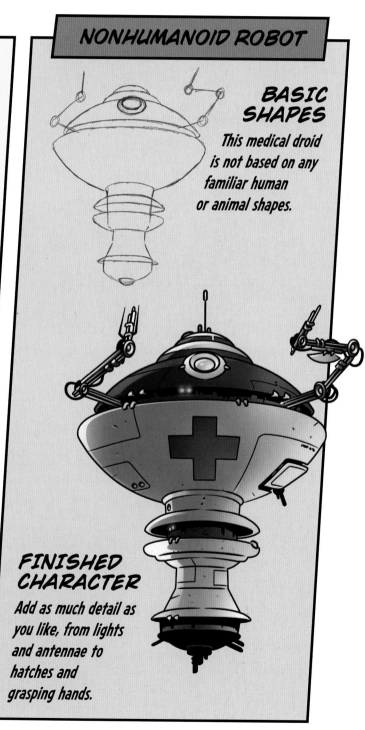

FINISHED CHARACTER

Add as much detail as you like, from lights and antennae to hatches and grasping hands.

DRAWING SPACESHIPS

SPACESHIPS CAN BE BIG AND BULKY OR SLEEK AND SLIMLINE. YOU CAN COPY THE BASIC SHAPES OF SHIPS FROM OBJECTS YOU FIND AROUND THE HOUSE, SUCH AS HAIR DRYERS OR KITCHEN APPLIANCES.

TRANSPORT SHIP

BASIC SHAPES

This ship is big and bulky, but we have made it narrow at the front.

FINISHED SHIP

The small details on this transport ship, for example, on its tower, give a sense of its size.

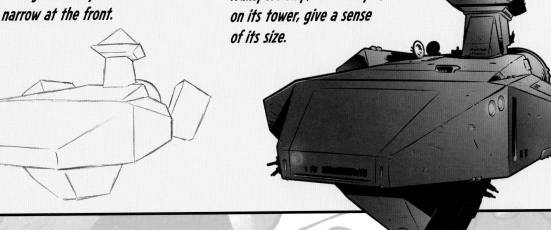

SPACE FIGHTER

BASIC SHAPES

A fighter ship has a pointed nose and several rocket engines behind.

FINISHED SHIP

It needs a hatch on top and battalion colors on the nose tip.

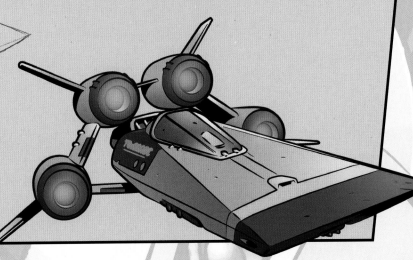

HOW TO DRAW
A GIANT MECHA

NO ONE MESSES WITH A MECHA! CREATE YOUR OWN GIANT ROBOTLIKE GIGANAUT HERE, IN THE BEST TRADITION OF JAPANESE SCIENCE FICTION. CONTROLLED BY A HUMAN PILOT, MECHA ARE BIG ENOUGH TO TACKLE GIANT THREATS, SUCH AS DINOSAURLIKE SPACE MONSTERS.

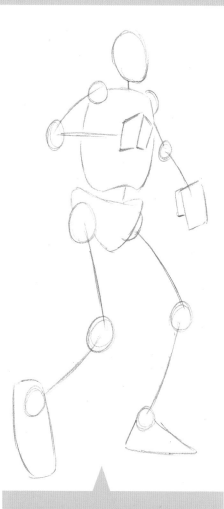

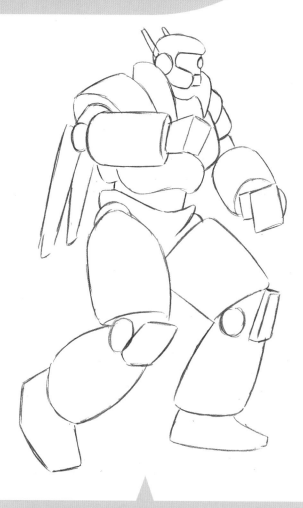

1 Start with a simple frame. Give your mecha a small head and long legs with huge feet for support.

2 Build on the frame using basic shapes. Begin to fill out your figure, bulking it up around the shoulders, forearms, and lower legs. Its upper torso should be broad, narrowing at the waist.

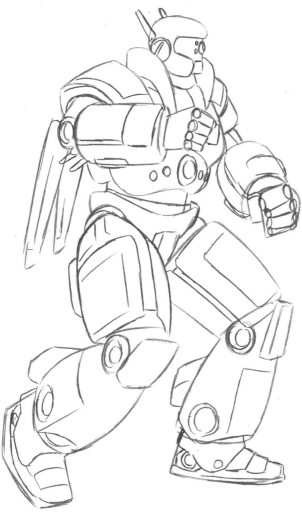

3 Sketch in details such as the fingers and rivets, keeping the mechanical feel of your creation. Add straight lines to show the armor plating on the feet and elsewhere. Keep his helmeted head small in comparison to his body.

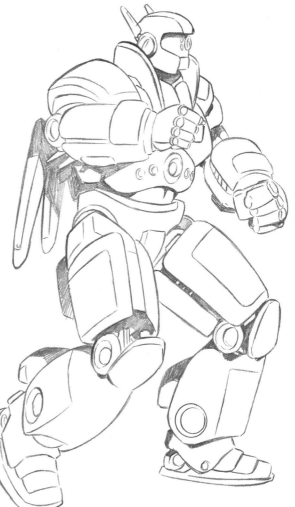

4 Although he's bulky, Giganaut is agile, and he can run faster than a bullet train. His range of movement is limited by his armor, but the shaded gaps at the knees, waist, elbows, and neck show his flexibility.

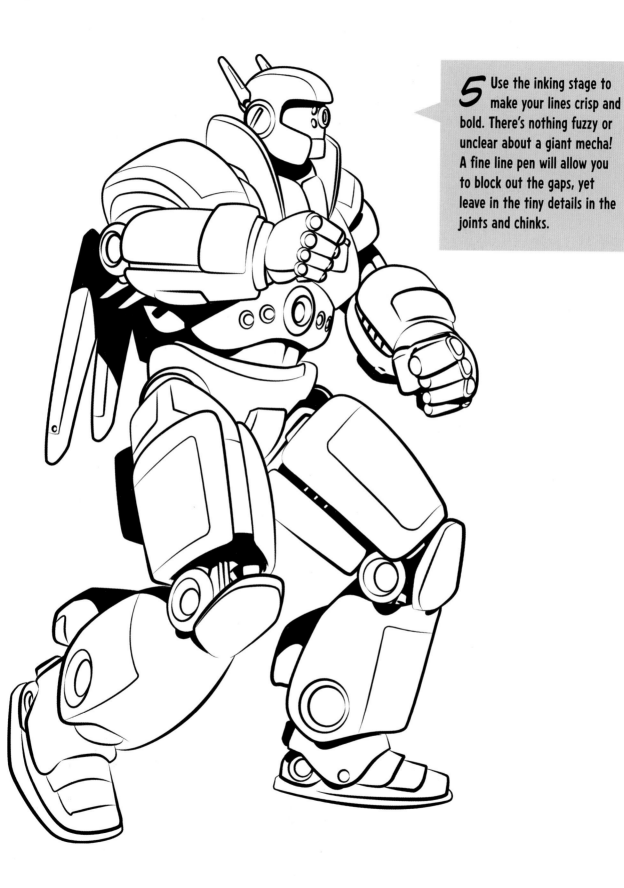

5 Use the inking stage to make your lines crisp and bold. There's nothing fuzzy or unclear about a giant mecha! A fine line pen will allow you to block out the gaps, yet leave in the tiny details in the joints and chinks.

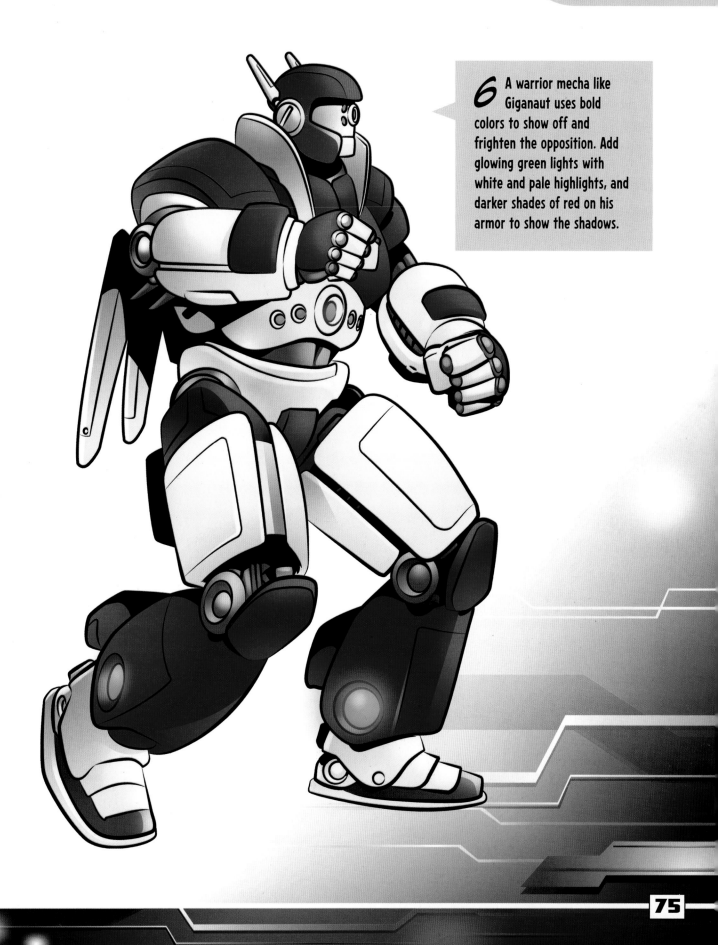

6 A warrior mecha like Giganaut uses bold colors to show off and frighten the opposition. Add glowing green lights with white and pale highlights, and darker shades of red on his armor to show the shadows.

A SCI-FI COMIC COVER

THE COVER OF A COMIC IS ITS MOST IMPORTANT ILLUSTRATION. AFTER ALL, YOU WILL WANT TO MAKE SURE THAT PEOPLE PICK UP YOUR STORY AND READ IT! IF YOU BREAK THE COVER DOWN INTO ITS PARTS, YOU WILL SOON REALIZE THAT IT'S LESS DIFFICULT THAN IT SEEMS AT FIRST.

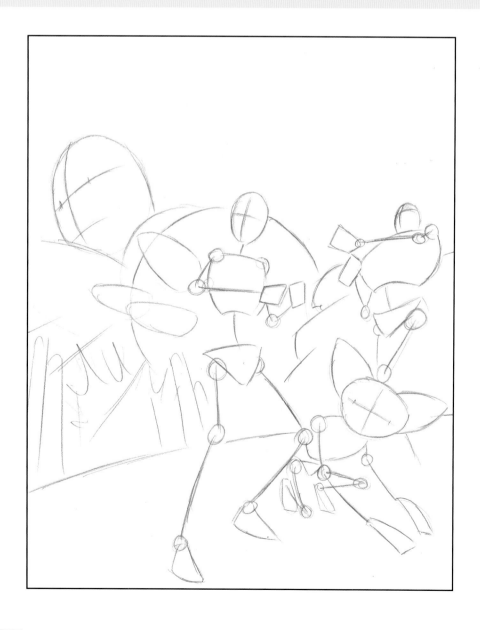

1 Start with the wireframe of your central character—we have chosen space pirate Xara. Then fill the rest of the cover with supporting characters. You can use other elements to create drama, as we have done with the spaceship and the giant enemy looming in the background.

2 Now flesh out your characters. Start with the foreground and work back, so that you know how much of any element is hidden by what's in front. Add some rough background detail, such as the building outlines and the billowing smoke cloud.

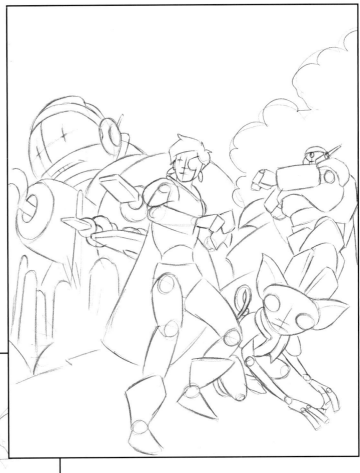

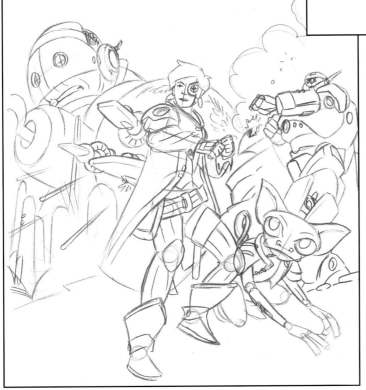

3 Add more detail to your characters. The mighty mecha, Giganaut, has less detail since he is farther away. Dream up a face for your huge villain. Give the scene some action with a couple of missiles shooting past.

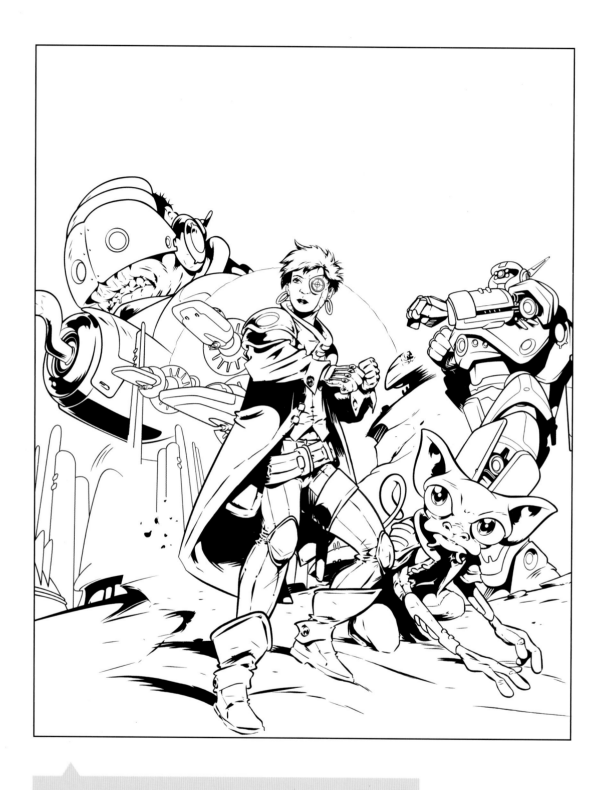

4 When you add ink, be careful not to go overboard. A large scene like this needs less detail on the background items, so that they don't draw attention away from, or clash with, your main characters.

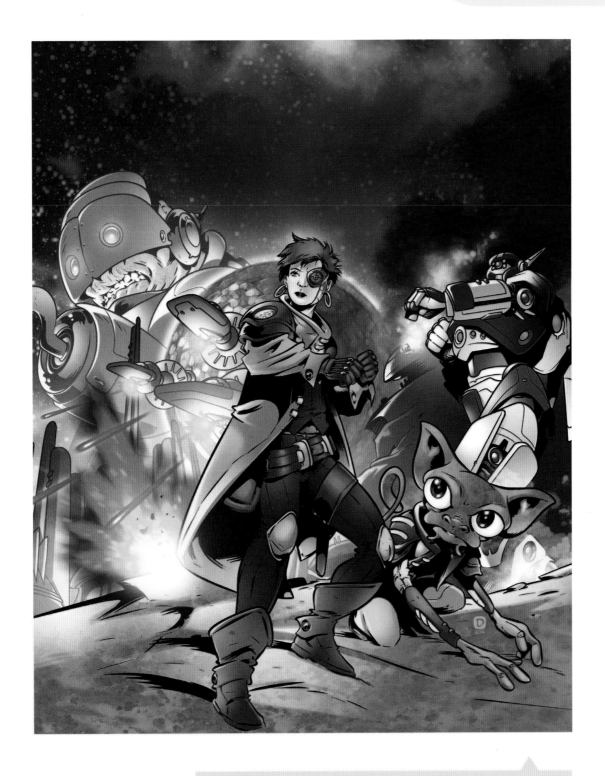

5 The whole scene is brightly lit from behind by the explosions. Vary the color of large areas, such as the sky. We have left a space at the top for the title of the comic. What will you call your masterpiece?

FANTASY COMICS

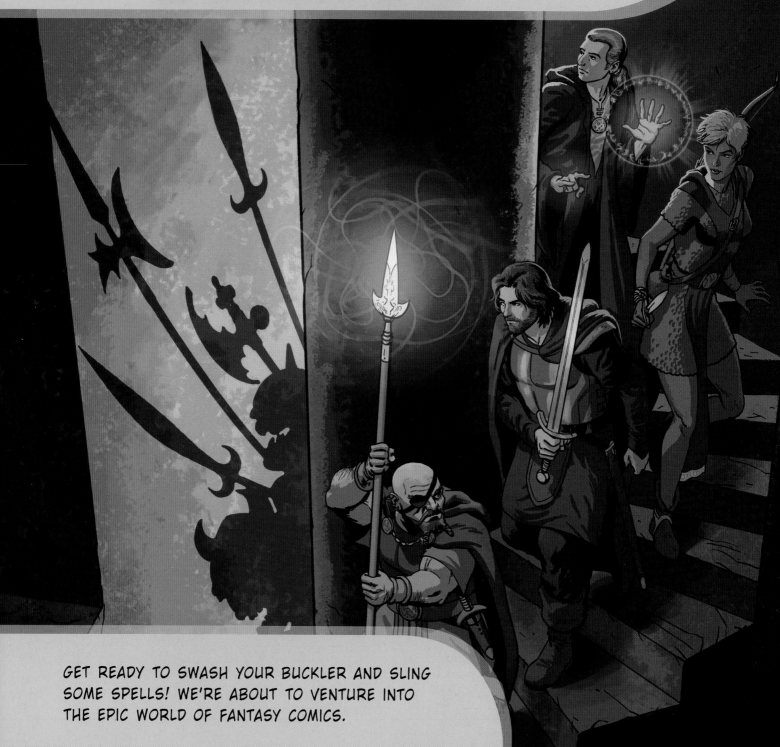

GET READY TO SWASH YOUR BUCKLER AND SLING SOME SPELLS! WE'RE ABOUT TO VENTURE INTO THE EPIC WORLD OF FANTASY COMICS.

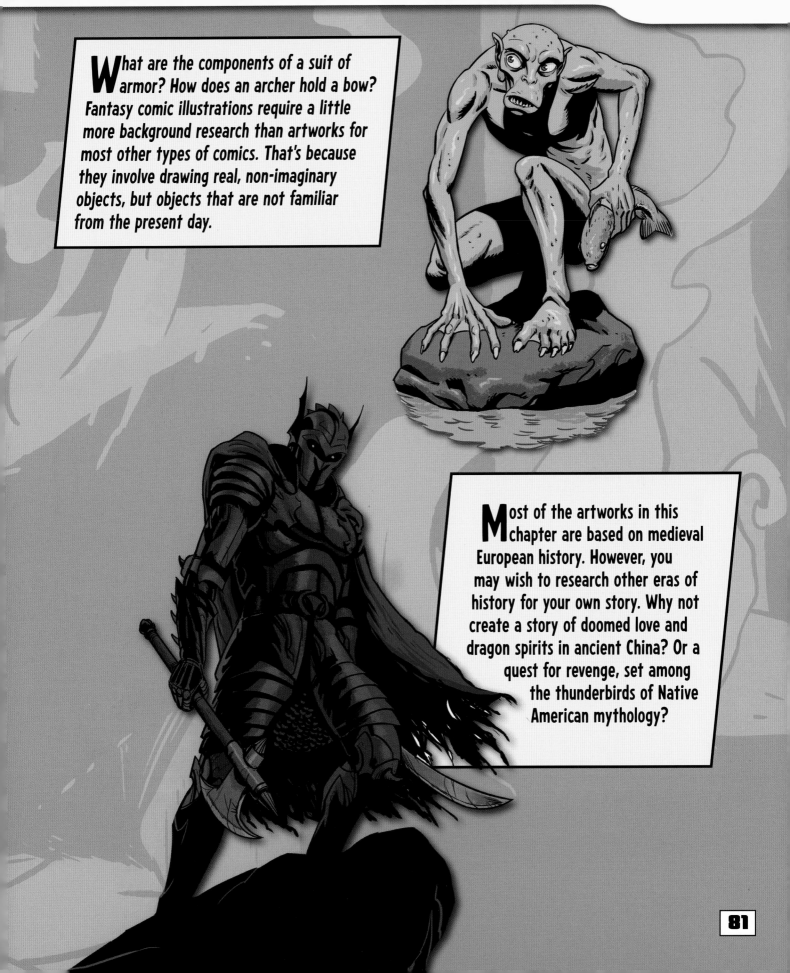

What are the components of a suit of armor? How does an archer hold a bow? Fantasy comic illustrations require a little more background research than artworks for most other types of comics. That's because they involve drawing real, non-imaginary objects, but objects that are not familiar from the present day.

Most of the artworks in this chapter are based on medieval European history. However, you may wish to research other eras of history for your own story. Why not create a story of doomed love and dragon spirits in ancient China? Or a quest for revenge, set among the thunderbirds of Native American mythology?

A MYSTERIOUS ROGUE

"THIS KINGDOM CAN BE A DANGEROUS PLACE," SAYS THE SWORDSMAN, "AND IF YOU'RE SETTING OFF ON A QUEST, THEN YOU'LL NEED A GUIDE." YOUR FIRST CHALLENGE IS TO CAPTURE THE IMAGE OF THIS FRIENDLY STRANGER. HIS NAME IS REX, AND HE'S A MYSTERIOUS ROGUE!

1 Sketch a wireframe to show your character's confident stance. Make sure you get his body proportions right.

2 Loosely pencil in the shape of his limbs, using long, sweeping strokes. Add lines to show the curve of his chest. Draw a cross on his head to show which way it is facing.

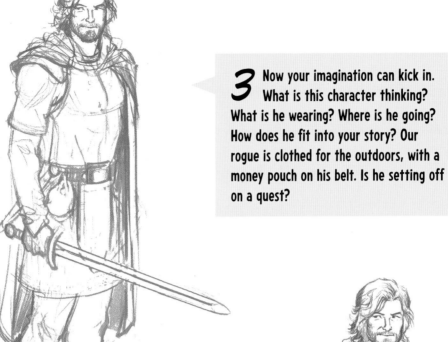

3 Now your imagination can kick in. What is this character thinking? What is he wearing? Where is he going? How does he fit into your story? Our rogue is clothed for the outdoors, with a money pouch on his belt. Is he setting off on a quest?

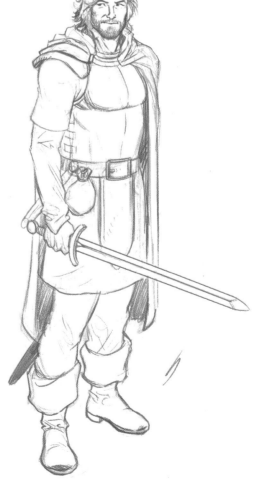

4 Firm up your lines, and erase any light sketching you no longer need. Show the folds of the cloak and the creases in his leather boots. Spend some time on his face to get his expression right. You can sense the twinkle in his eye.

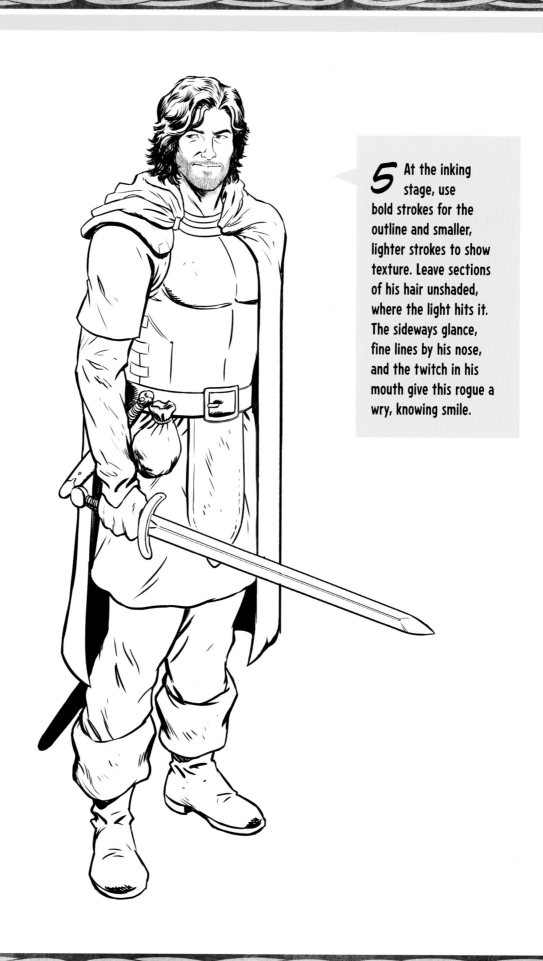

5 At the inking stage, use bold strokes for the outline and smaller, lighter strokes to show texture. Leave sections of his hair unshaded, where the light hits it. The sideways glance, fine lines by his nose, and the twitch in his mouth give this rogue a wry, knowing smile.

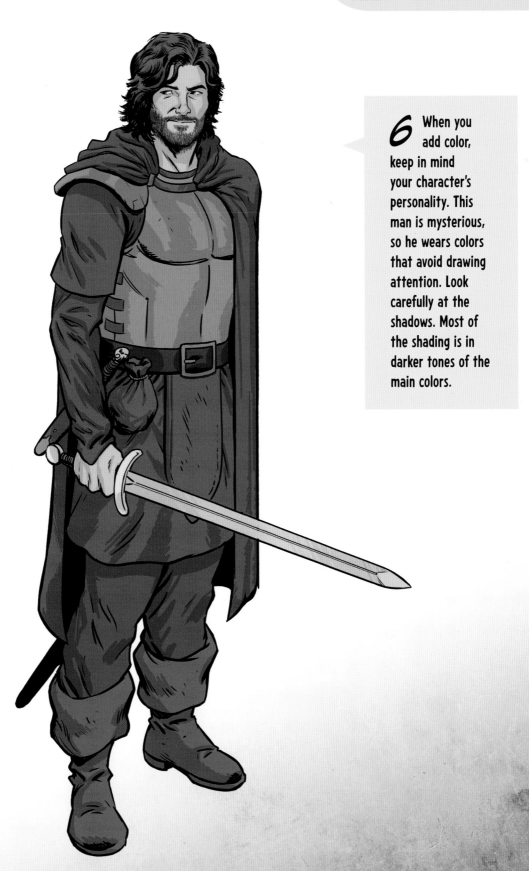

6 When you add color, keep in mind your character's personality. This man is mysterious, so he wears colors that avoid drawing attention. Look carefully at the shadows. Most of the shading is in darker tones of the main colors.

FANTASY WEAPONS AND ARMOR

YOUR FANTASY HEROES WILL NEED TO BE WELL-ARMED! YOU CAN TAKE INSPIRATION FROM DIFFERENT WEAPONS THROUGHOUT HISTORY. YOU HAD BETTER THINK ABOUT SOME PROTECTIVE GEAR, TOO ...

BECOME A MASTER SWORDMAKER

You can give your fantasy art a realistic edge by thinking about the details of your characters' equipment. Not all swords are made the same way! What kind of blades and hilts will your characters' swords have?

STRAIGHT SWORDS

A short sword (near left) is made for thrusting, and it may have a guard to protect the hand. A long sword (far left) is swung with both hands, so it needs a long handle.

CURVED SWORDS

Cutlasses (right) have a wide guard and a slightly curved blade for slashing.

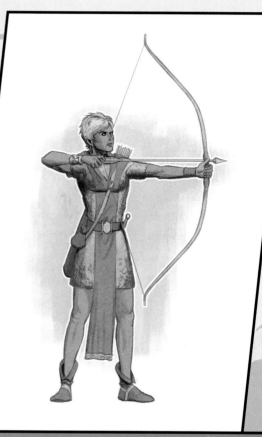

MAKE YOUR ARCHERY HIT THE BULLSEYE

When someone is using a bow, their arms are raised high, with the hands in line with each other. The rear elbow is pulled back at a sharp angle, and the head is straight but able to "kiss the string" of the bow. Feet are shoulder-width apart for balance.

POLISH UP YOUR ARMOR

FULL METAL PLATES

The vulnerable parts of the body are protected with heavy, stiff metal.

MAIL OR CHAIN MAIL

This is made of thousands of tiny metal rings.

LEATHER ARMOR

This primitive armor is made up of breast panels, cuffs, and a skirt.

The armor worn by your characters speaks volumes about their wealth, status, and fighting ability. It can also say something about their history or backstory: Where have they come from? Is the character a veteran of many campaigns, or have they been thrown into battle against their will?

READYING YOUR SHIELD

You can really have fun with decorating shields. What will the emblem say about your character or their family? Small shields are used to parry and fight back. Large shields provide the best protection.

BUCKLER

This is a small, round shield, gripped tightly in the fist to deflect the blow of a sword or mace.

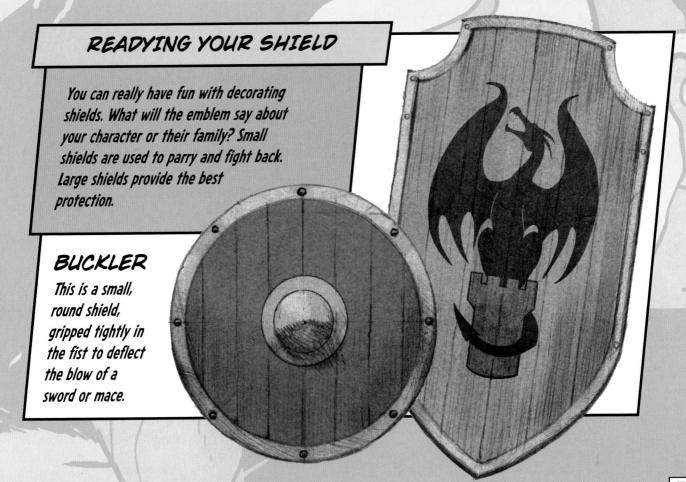

A WOOD-ELF RANGER

THIS FEISTY RANGER MAY NOT BE HEAVILY ARMED, BUT SHE'S NO PUSHOVER. RAVEN SUMMERGLADE IS STRONG AND ATHLETIC, AND SHE'S A MEAN SHOT WITH HER LONGBOW. IT WOULD TAKE A FOOLISH FOE TO TACKLE HER WITH HER DRAGON AT HER SIDE.

1 Sketch the elf first, standing relaxed with her bow in hand. Then arrange the young dragon's body and wings around her.

2 Go over your framework, adding the lines of the elf's body and limbs. Flesh out the dragon's tail and head, adding clawed feet and wings held in a folded position.

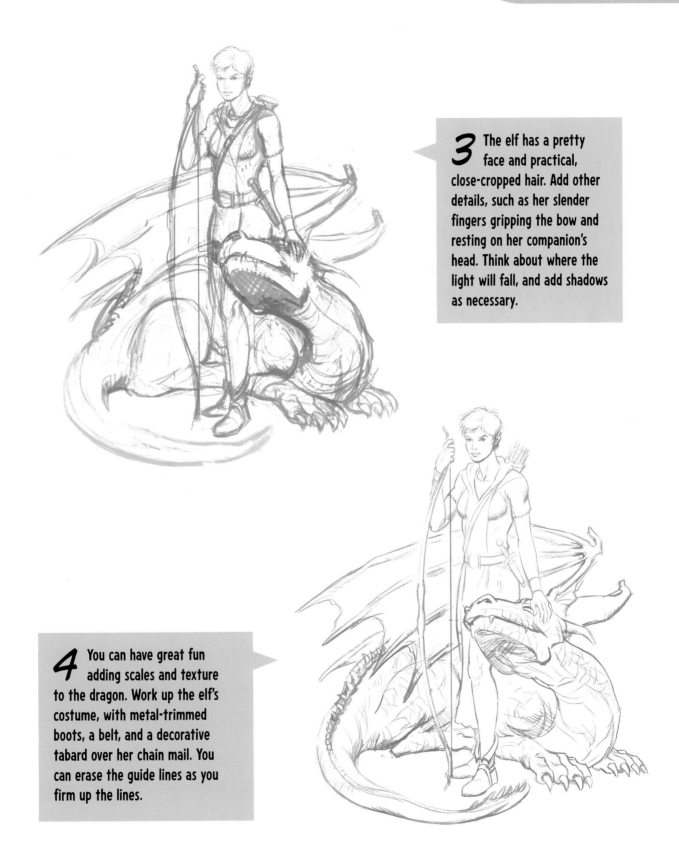

3 The elf has a pretty face and practical, close-cropped hair. Add other details, such as her slender fingers gripping the bow and resting on her companion's head. Think about where the light will fall, and add shadows as necessary.

4 You can have great fun adding scales and texture to the dragon. Work up the elf's costume, with metal-trimmed boots, a belt, and a decorative tabard over her chain mail. You can erase the guide lines as you firm up the lines.

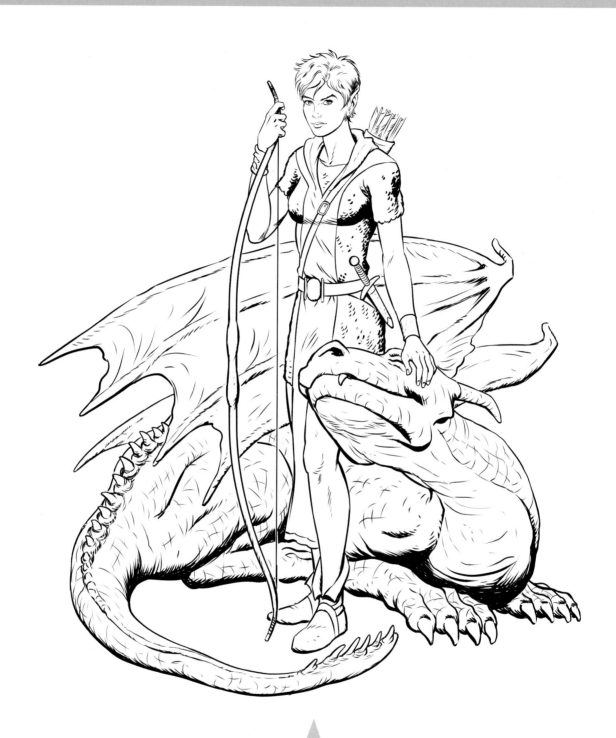

5 Ink over your pencil sketch carefully. Use very fine lines for the elf's facial features. Each claw and spike of the dragon should be precise and neat. Don't rush! There are many small details involved, and you don't want to ruin your hard work.

6 You don't have to follow normal rules when it comes to coloring fantasy characters. This young ranger has dark skin but silver hair. Match the underside of her dragon's wing to the shades on its belly, with a deeper forest green on top.

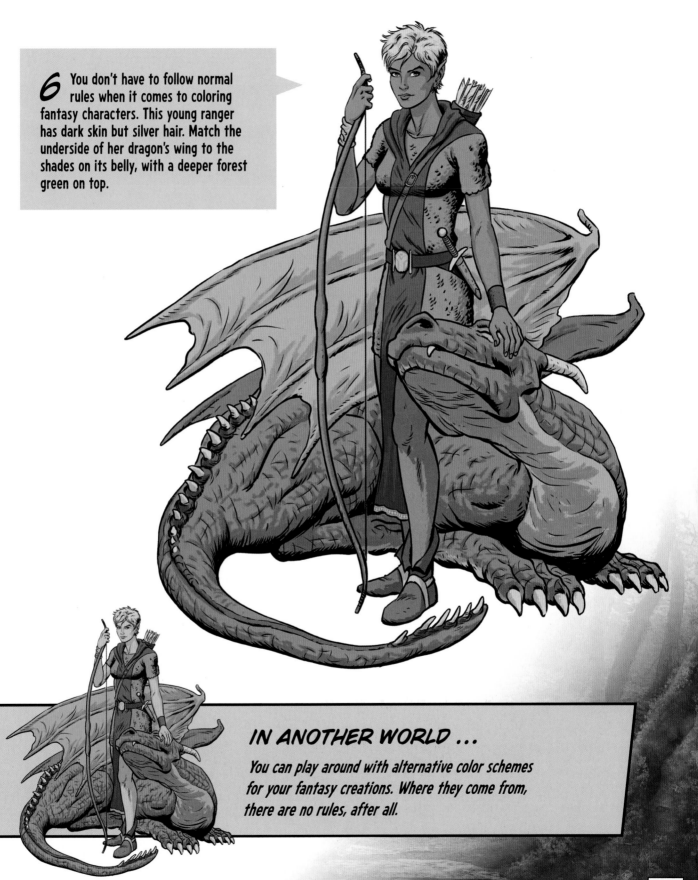

IN ANOTHER WORLD ...

You can play around with alternative color schemes for your fantasy creations. Where they come from, there are no rules, after all.

DRAWING VARIED BUILDS

MANY OF YOUR CREATURES WILL HAVE A NONHUMAN FORM. YOU CAN PLAY AROUND WITH PROPORTIONS, CHANGING THE LENGTH OF LIMBS, SIZE OF THE HEAD, AND SO ON, FOR GREAT EFFECTS.

APELIKE CHARACTERS

This swamp troll has long, apelike limbs and a hunched posture. You can use this type of build for creatures such as orcs, goblins, and other primitive beings.

1 Start with a simple frame. The legs are bent and unusually long, and the body is stooped down low to the ground.

2 Flesh out the body, but not too much. The creature is thin and wiry—he looks hungry! Add claws and webbed feet and hands for a water-dwelling lifestyle.

SMALL CHARACTERS

Many fantasy stories feature characters with a short and stocky build, such as ancient dwarves that are as tough as nails. For the example here, we are using a halfling thief.

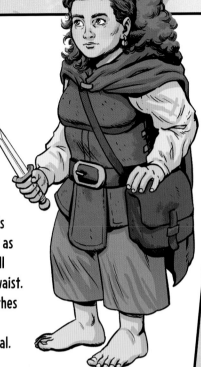

1 Here, the legs are only two heads high, and the body is just as compact. The feet look large in comparison.

2 Her body is squat, but as a female, she still narrows at the waist. Her hair and clothes are shorter and wider than normal.

HUGE AND MUSCULAR CHARACTERS

Here is a foul-tempered, brutish mountain troll. You could use this type of heavyset build for big and tough but stupid and slow-moving creatures such as ogres, giants, and Minotaurs.

1 The troll has a barrel chest and rounded stomach. Notice how long his arms are and what a small head he has.

2 The lines sketched on his muscles add to the impression of strength and weight. Use plenty of definition on his limbs and body.

A DWARF WARRIOR

THIS WARRIOR WAS ONCE A MONK, BUT NOW HE'S LIVING THE LIFE OF A PROFESSIONAL MONSTER HUNTER. PATCH IS TINY BUT TOUGH AND WILL TAKE ON ANY OPPONENT, LARGE OR SMALL. THAT'S THE BENEFIT OF CARRYING A LONG—AND MAGICAL—SPEAR.

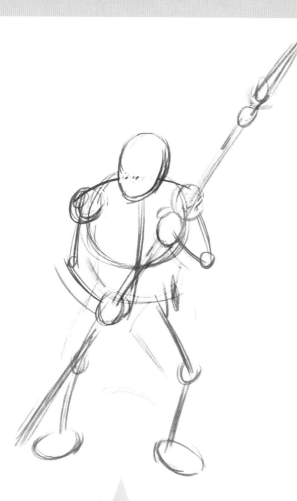

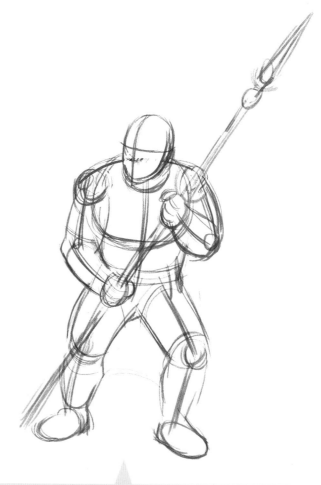

1 Use your frame to show that the character is ready and alert, with his weight on his front foot, poised for action.

2 Draw a cross on the head, so that you can position the dwarf's features correctly. Add outlines for his limbs, giving him strong-muscled upper arms and chunky calves and thighs.

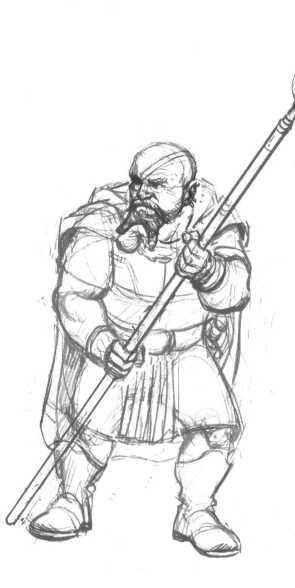

3 Think about your character as you sketch in the important details. Our warrior has lost an eye at some point in his colorful history, so he wears an eye patch. He has a shaved head but an ornate beard, and the look of a battle-hardened warrior.

4 Now you can begin to remove some of your rough guide lines. Firm up the details and erase anything unnecessary. Use heavy shading to show the lines of his cloak and his sturdy boots. Finish his beard and face with fine lines.

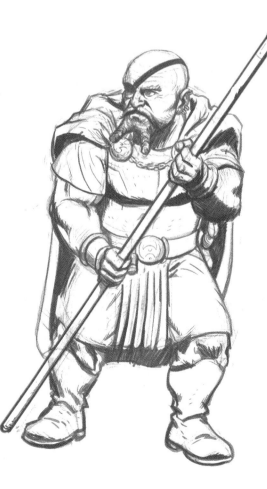

5 For the inked version, use solid shading on the underside of his arms, chest, and chin and around the knees. Blacken his eye patch, and give his good eye a menacing glint. Decorate his buckles and spear to make them his own custom design.

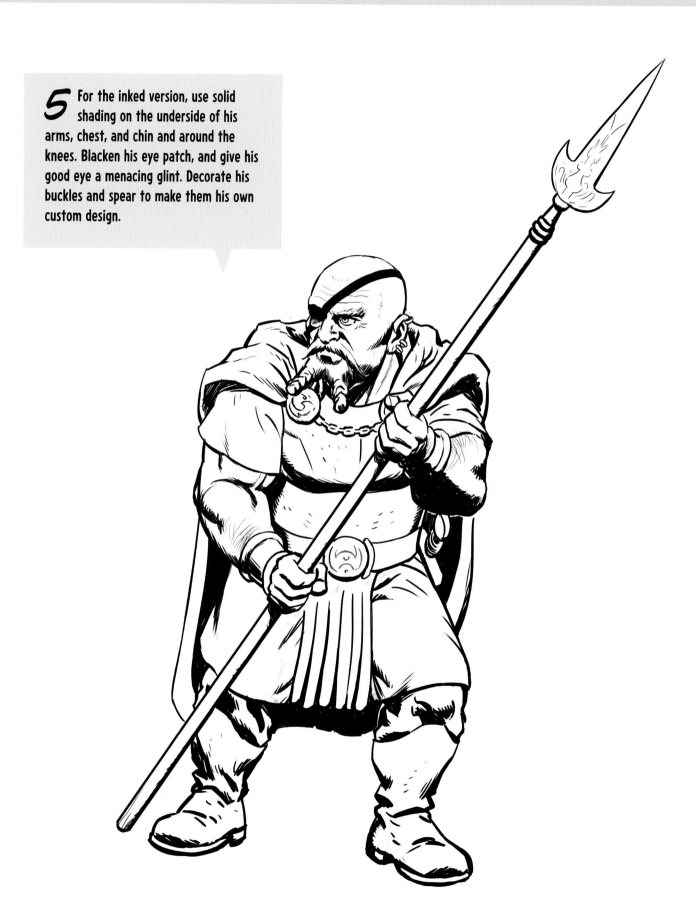

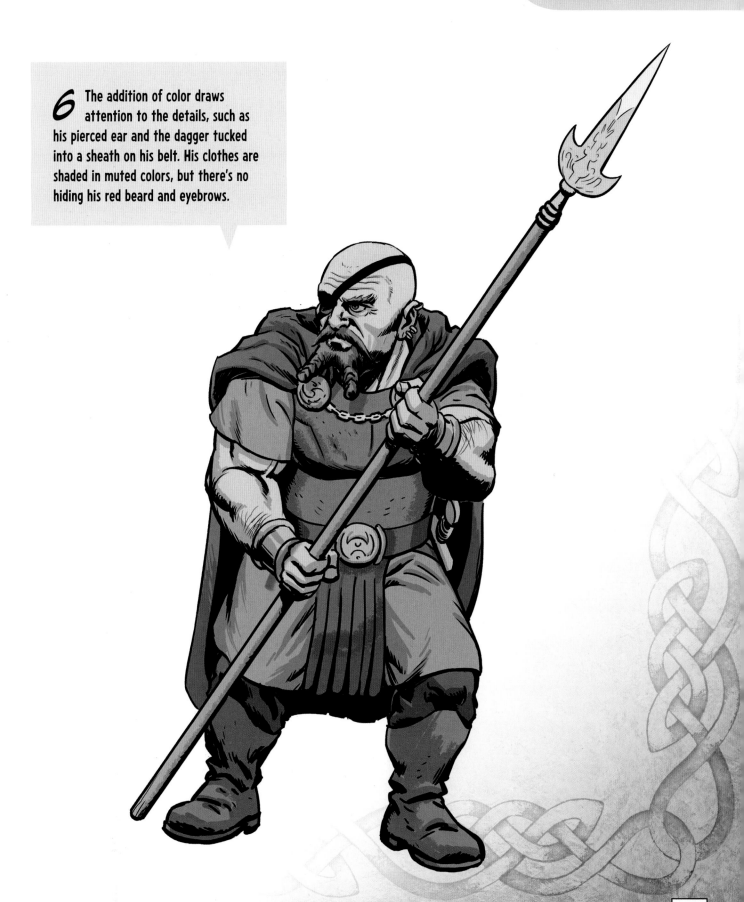

6 The addition of color draws attention to the details, such as his pierced ear and the dagger tucked into a sheath on his belt. His clothes are shaded in muted colors, but there's no hiding his red beard and eyebrows.

USING PERSPECTIVE IN SCENES

THE USE OF PERSPECTIVE IS AN IMPORTANT SKILL TO MASTER. IT WILL GIVE A FEELING OF DEPTH TO YOUR SCENES, AND IT IS ESPECIALLY IMPORTANT FOR DRAWING BUILDINGS AND TOWNS.

VANISHING POINT

The straight lines in the scene all meet at a faraway "vanishing point."

PERSPECTIVE LINES

These straight lines show how the buildings should be positioned.

HORIZON

The vanishing point should be placed along an imaginary horizon line.

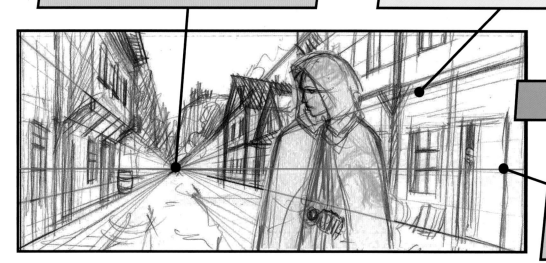

FORESHORTENING

Things that are closer are drawn larger than things far away. This is known as foreshortening, and it creates the illusion of depth. The buildings along this street become tiny in the distance.

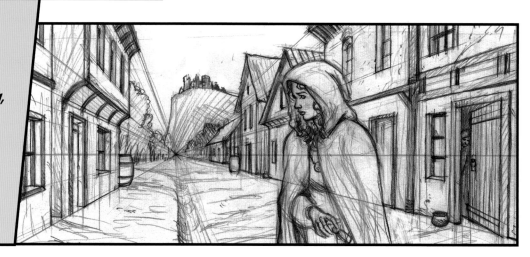

WORM'S-EYE VIEW

Now imagine you are viewing a scene from below. The scene has one low vanishing point, across the drawbridge, and another high above the castle, which seems to stretch into the sky.

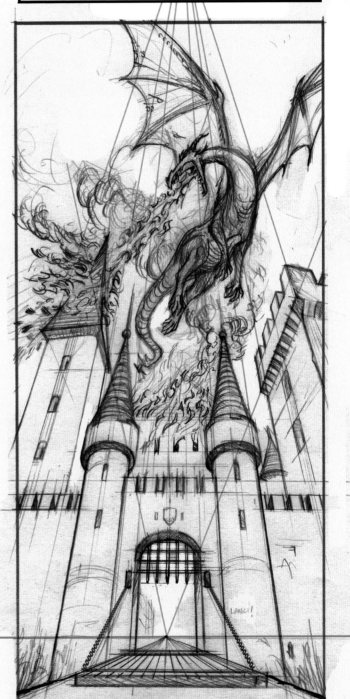

BIRD'S-EYE VIEW

This picture is drawn as if you are looking at it from high above. It uses two-point perspective, with two vanishing points in different places. Foreshortening makes the tower look smaller than the bird.

A WIZARDS' BATTLE

NOW YOU CAN PULL TOGETHER EVERYTHING YOU HAVE LEARNED ABOUT CHARACTERIZATION, PROPORTIONS, POSTURE, AND PERSPECTIVE IN ONE DRAMATIC SCENE. THE QUICK-WITTED YOUNG WIZARD, JARYTH, IS SHOWN HERE IN THE MIDST OF A BATTLE AGAINST THE EVIL QUEEN OF ASHES.

1 Decide on your vanishing point. Use the lines of the staircase to set up your perspective. Sketch the basic frames for Jaryth and the Queen, her minions, and the background.

2 Gradually build up the layers of detail in the foreground and background. Now concentrate on your characters. Jaryth is closer to the viewer, so he appears larger than the Queen of Ashes. Add in the details of clothing and the magical "special effects" for the fight.

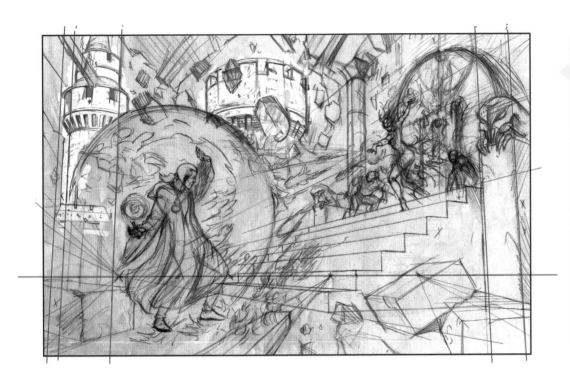

3 When you're satisfied with the way the scene is shaping up, you can think more about textures and plan the way that lighting will cast shadows. Add detail to the fiery shield and the pieces falling from the roof.

4 The inked artwork is dramatic, with strong contrasts of light and dark (this is called "chiaroscuro"). There are no unnecessary lines or shading, but the viewer can spot details like the statues and hooded figures as they take a closer look.

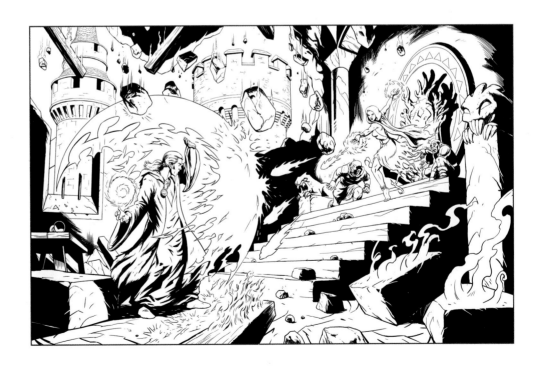

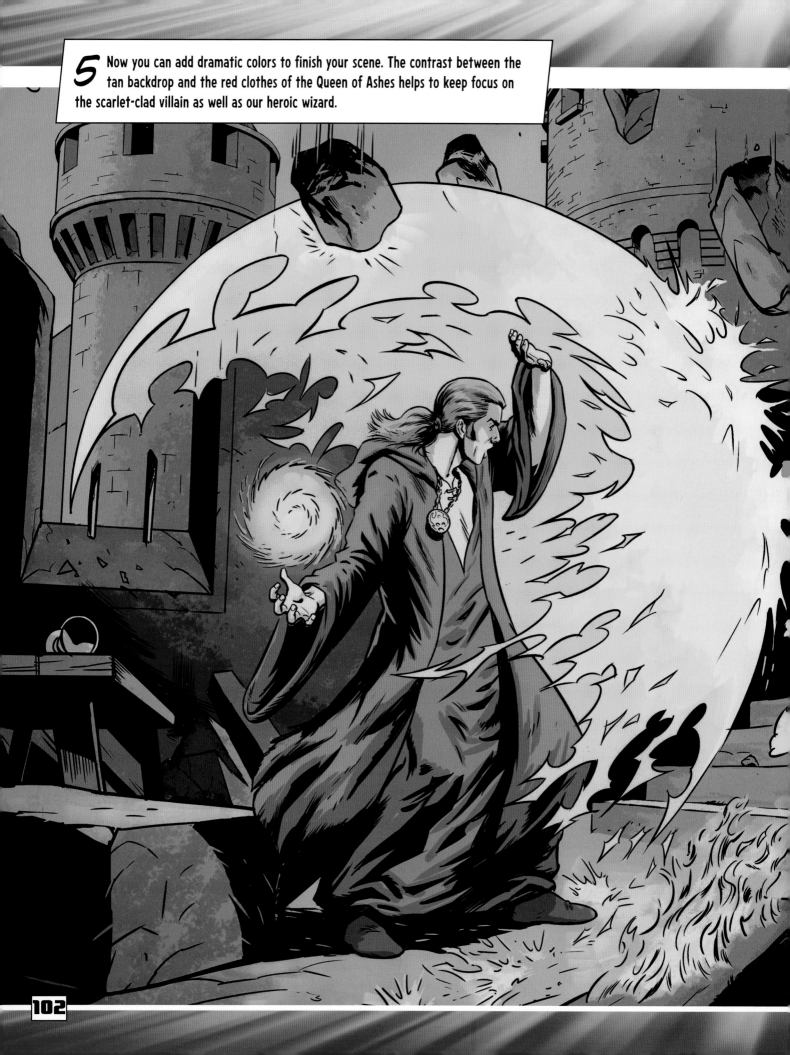

5 Now you can add dramatic colors to finish your scene. The contrast between the tan backdrop and the red clothes of the Queen of Ashes helps to keep focus on the scarlet-clad villain as well as our heroic wizard.

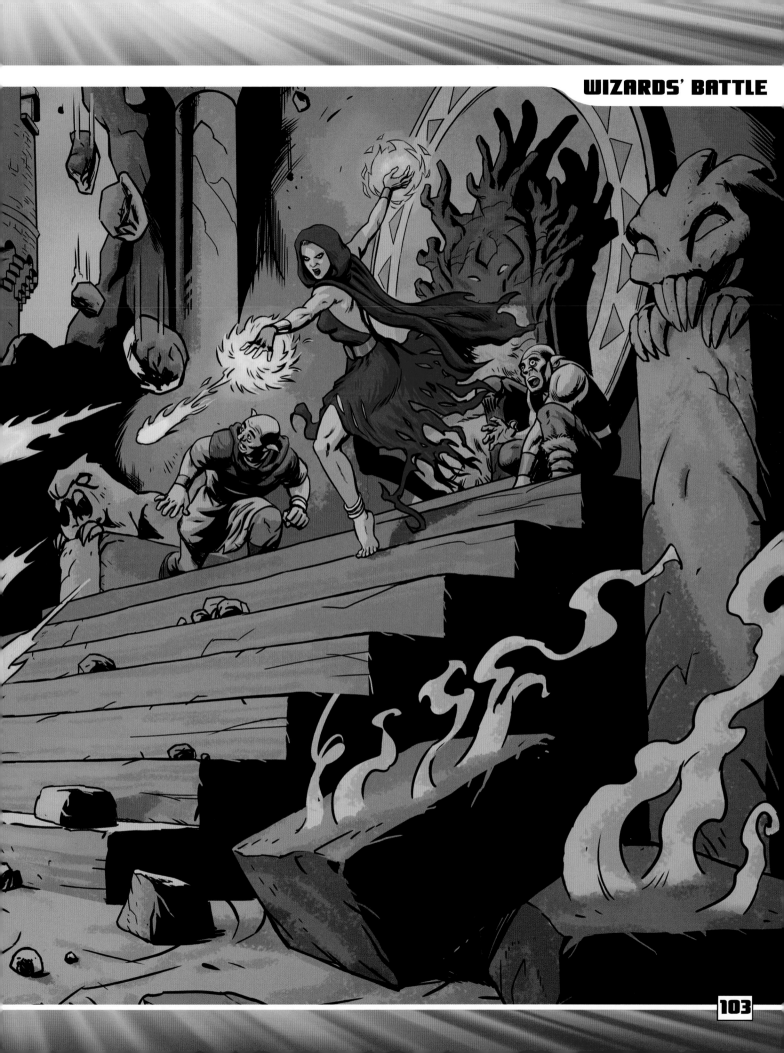

HORROR COMICS

DRAW NEAR, WEARY TRAVELER, FOR OUR FINAL,
CHILLING CHAPTER! DO YOU FEEL BRAVE ENOUGH
TO TACKLE SOME ADVANCED SKILLS IN COMIC
STORYTELLING?

We've previously covered various different aspects of drawing backgrounds and scenes. But what is a scene without an atmosphere? In this chapter, you'll discover how to use inking to create mysterious and sinister moods.

You already know how to show heroes in action. But how do you make a character perform like an Oscar-winning actor? You'll find some handy tips in the "Expressions and Body Language" section.

The final part of this chapter describes how to put together a page with multiple panels. You can use these skills to create a masterpiece of horror storytelling ... or apply the same rules to any other comic story!

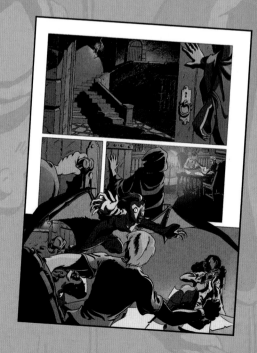

SHADOWS AND ATMOSPHERE

A SCENE CAN BE COMPLETELY TRANSFORMED BY THE EFFECTIVE USE OF SHADOWS. A SETTING THAT WOULD APPEAR ORDINARY OR EVEN WELCOMING IN GOOD LIGHTING CAN SUDDENLY BECOME MYSTERIOUS AND SINISTER.

A SCENE WITHOUT SHADOWS

This library scene could be any ordinary library, although the costumes give a visual clue that it is a historical setting. The light source is unclear: Is light streaming through the stained-glass window or coming from the ceiling lamp?

A SCENE WITH SHADOWS

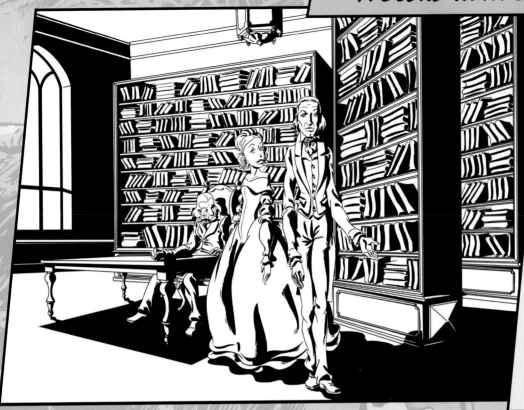

The artist has added some shadows to this inked version of the image. It feels much more atmospheric, though it is not necessarily a horror scene. The shadows are cast by the books, people, and furniture as the light shines in through the large window on the left.

A SCENE WITH HEAVY SHADOWS

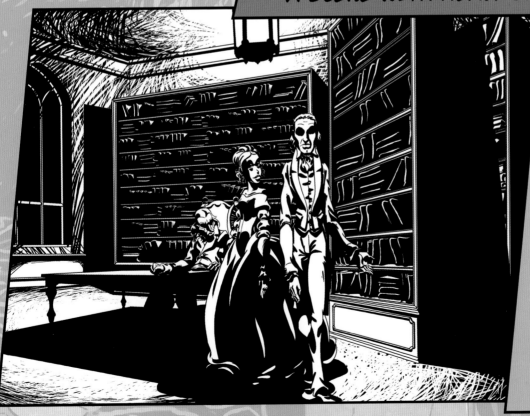

Now it's clearer that our scene is spine-chilling and spooky! Much of the room is inked out in shadow, allowing us to focus on the characters in the foreground. The bold contrast between light and dark is often called chiaroscuro.

HOW TO DRAW

A SWAMP ZOMBIE

THIS CREEPY CREATURE HAS BEEN LYING IN WAIT BENEATH THE FOUL, STAGNANT WATERS OF AN ANCIENT SWAMP. NOW IT HAS FINALLY EMERGED, AND IT LOOKS LIKES IT'S HUNGRY FOR HUMAN FLESH! CAN YOU CAPTURE ITS FRIGHTENING POSE AND EXPRESSION?

1 Use a wireframe to plan how you want your creature to stand and how long its limbs will be. It's tall and skinny.

2 Develop the hands and feet, with fingers and toes. Use curved lines to outline the thin legs and arms. Connect the hips and chest with a narrow waist, and sketch in facial features.

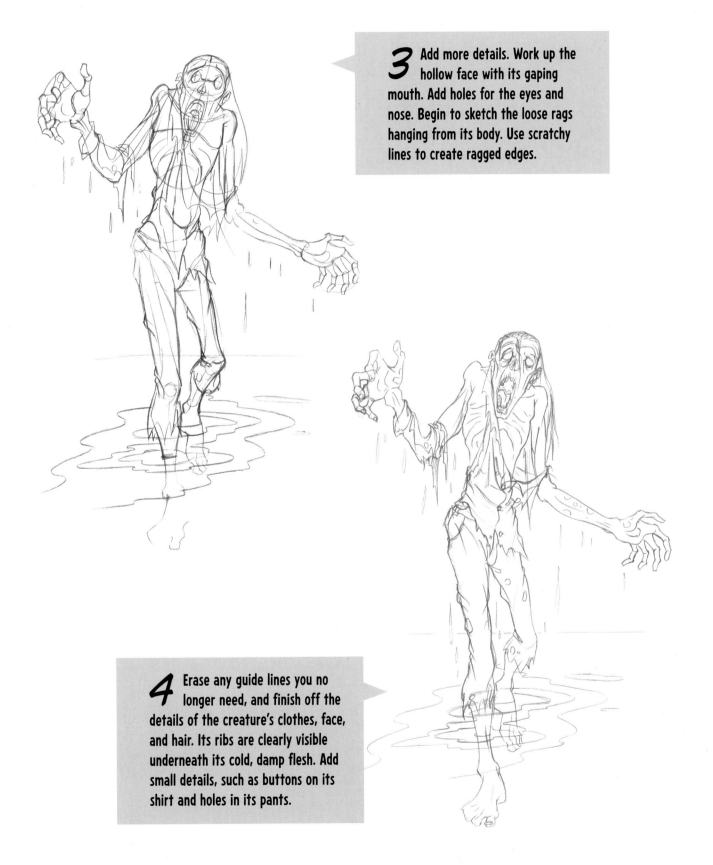

3 Add more details. Work up the hollow face with its gaping mouth. Add holes for the eyes and nose. Begin to sketch the loose rags hanging from its body. Use scratchy lines to create ragged edges.

4 Erase any guide lines you no longer need, and finish off the details of the creature's clothes, face, and hair. Its ribs are clearly visible underneath its cold, damp flesh. Add small details, such as buttons on its shirt and holes in its pants.

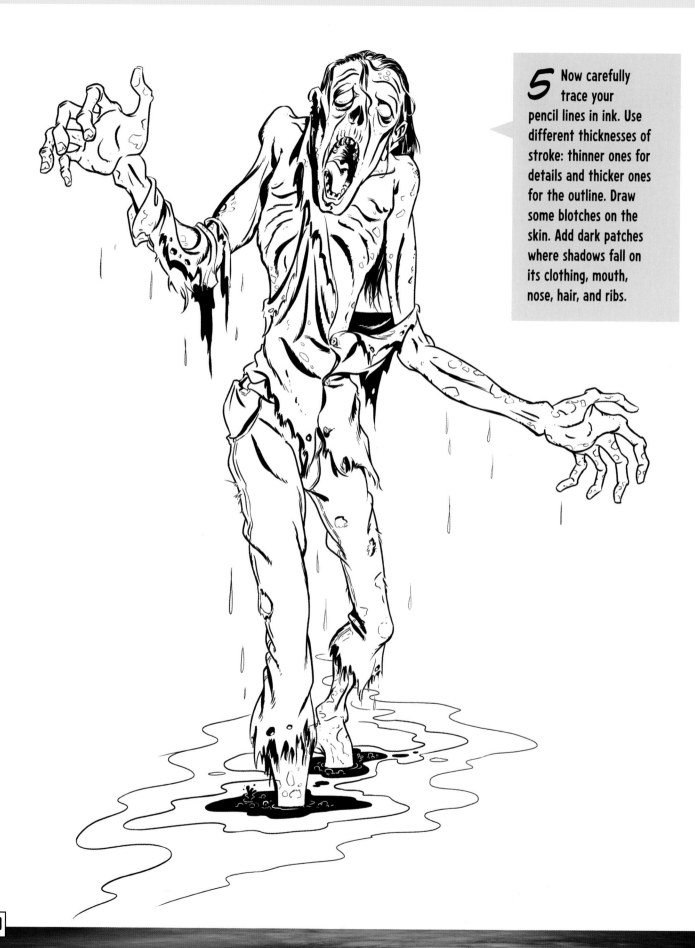

5 Now carefully trace your pencil lines in ink. Use different thicknesses of stroke: thinner ones for details and thicker ones for the outline. Draw some blotches on the skin. Add dark patches where shadows fall on its clothing, mouth, nose, hair, and ribs.

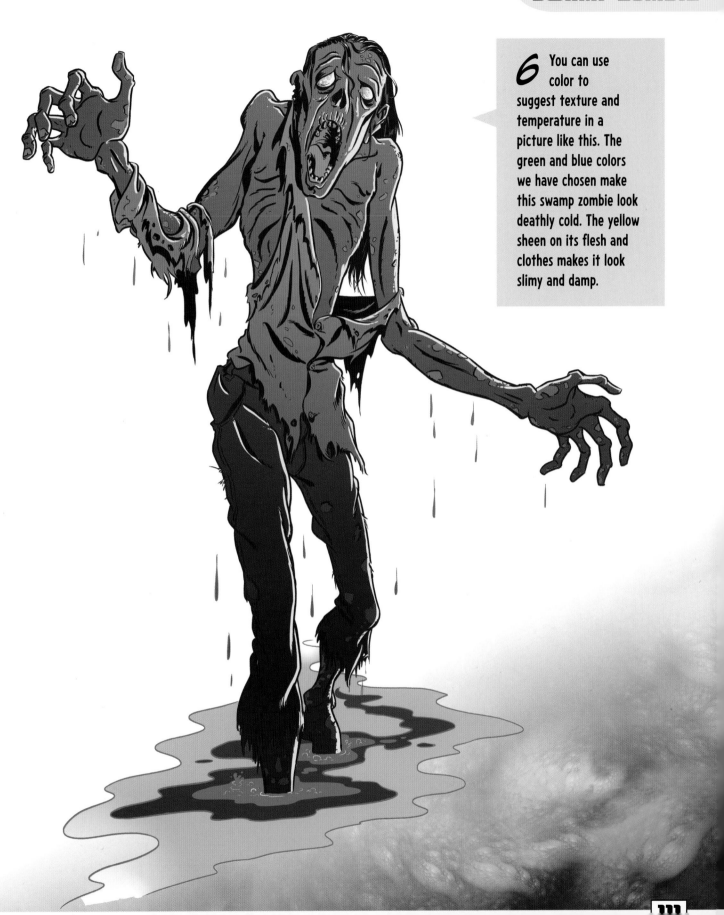

6 You can use color to suggest texture and temperature in a picture like this. The green and blue colors we have chosen make this swamp zombie look deathly cold. The yellow sheen on its flesh and clothes makes it look slimy and damp.

EXPRESSIONS AND BODY LANGUAGE

TO CREATE A SENSE OF ATMOSPHERE IN A HORROR COMIC, YOU WILL NEED TO BE ABLE TO MAKE YOUR CHARACTERS PERFORM LIKE ACTORS! BY SHOWING HOW THEY RESPOND TO A SITUATION, YOU CAN MAKE READERS CARE ABOUT WHAT IS HAPPENING.

RELAXED

This character looks cool, calm, and collected. Her arms are hanging loosely, and there is no tension in her shoulders or elbows. She has a warm and open smile.

NERVOUS

This woman's wide eyes and raised hands show she is worried about something. Her shoulders are tense and she leans forward, ready to run if necessary.

SCARED

This guy is terrified! He has thrown up his hands to ward off danger and his eyebrows have shot right up. His eyes and mouth show his fear. He looks like he is ready to leap backward.

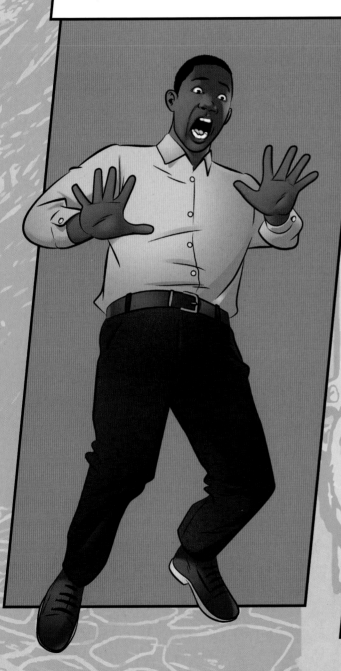

CONFIDENT

If this dude is scared, he's not showing it! With his feet apart and his hands curled into fists, he's ready to take on any monsters. The determined look on his face says he's a hero.

HOW TO DRAW
A HAUNTED SCARECROW

THIS PUMPKIN-HEADED SCARECROW HAS BEEN BROUGHT TO LIFE BY A SPIRIT OF VENGEANCE FROM BEYOND THE GRAVE. BEWARE OF ITS CLAWLIKE HANDS AND SHARP-PRONGED PITCHFORK! WHAT KIND OF SPOOKY STORIES WILL IT INSPIRE YOU TO ILLUSTRATE?

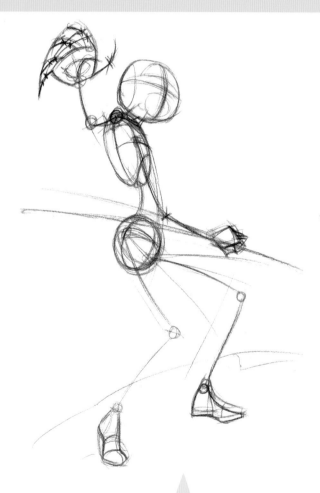

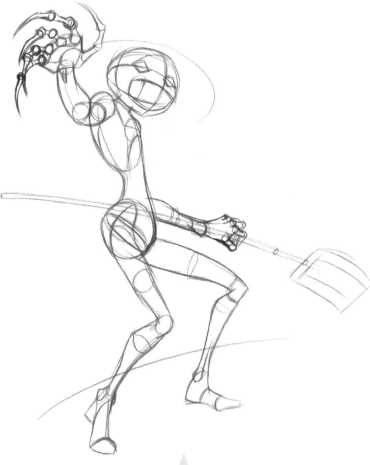

1 Body language plays an important role in making a creature look sinister. Is this scarecrow warning us away from something?

2 Bulk out its frame, giving definition to its skinny arms and legs. Take time to sketch each joint and knuckle for its outstretched, clawlike hand.

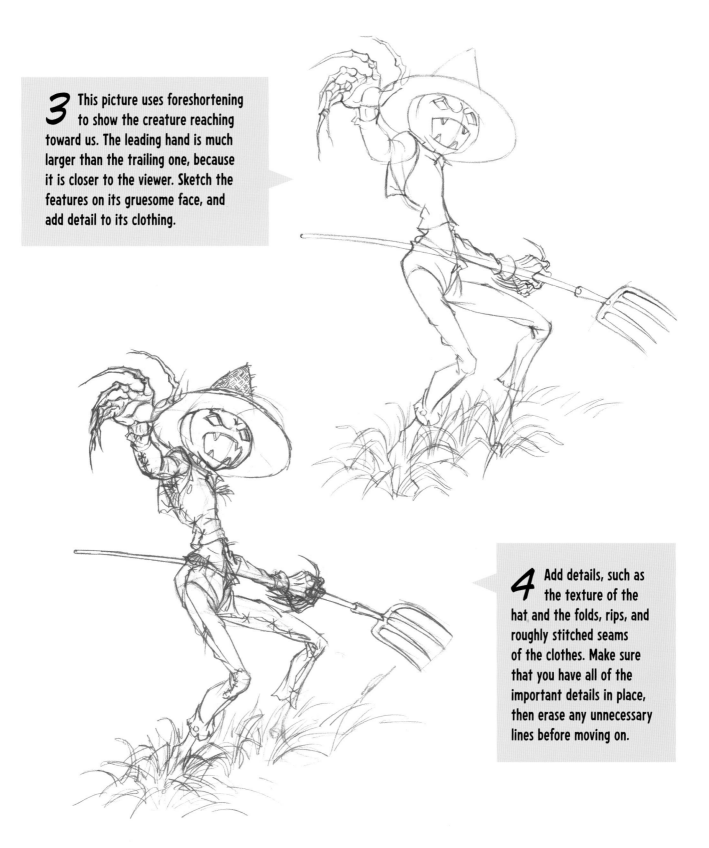

3 This picture uses foreshortening to show the creature reaching toward us. The leading hand is much larger than the trailing one, because it is closer to the viewer. Sketch the features on its gruesome face, and add detail to its clothing.

4 Add details, such as the texture of the hat and the folds, rips, and roughly stitched seams of the clothes. Make sure that you have all of the important details in place, then erase any unnecessary lines before moving on.

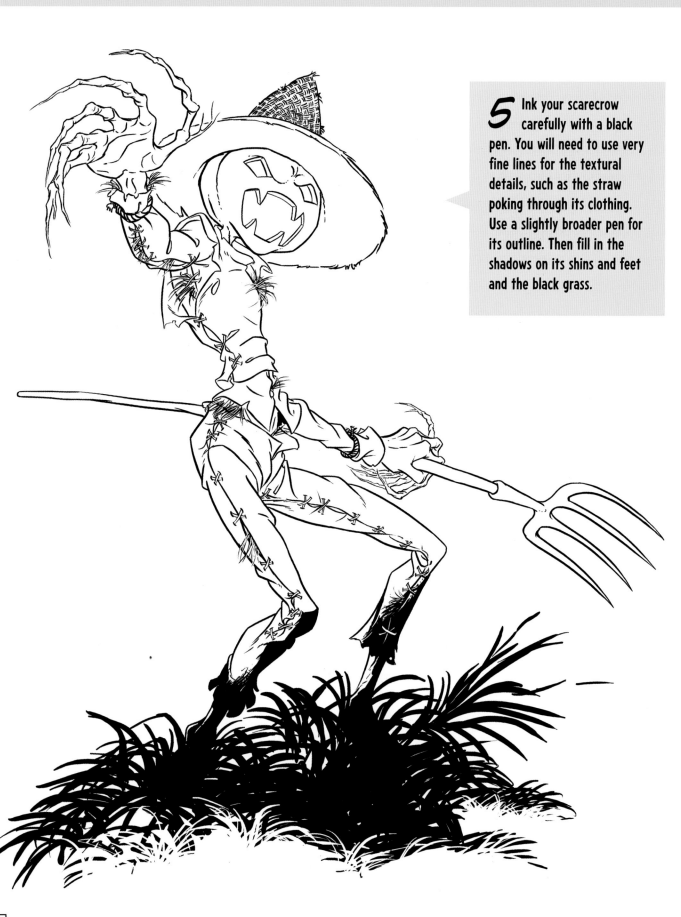

5 Ink your scarecrow carefully with a black pen. You will need to use very fine lines for the textural details, such as the straw poking through its clothing. Use a slightly broader pen for its outline. Then fill in the shadows on its shins and feet and the black grass.

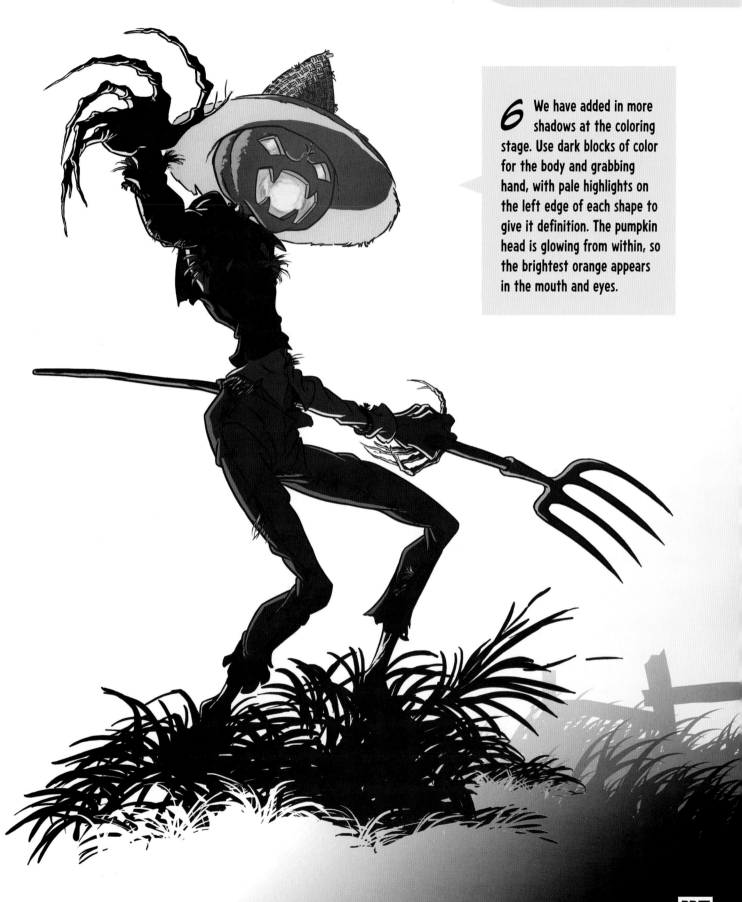

6 We have added in more shadows at the coloring stage. Use dark blocks of color for the body and grabbing hand, with pale highlights on the left edge of each shape to give it definition. The pumpkin head is glowing from within, so the brightest orange appears in the mouth and eyes.

TELLING A HORROR STORY

THERE ARE MANY DIFFERENT WAYS TO TELL A COMIC STORY. AN ARTIST IS LIKE A FILM DIRECTOR AND MUST CHOOSE THE BEST ANGLES AND DISTANCES FOR EACH PANEL. IN THIS SHORT STORY, WE SHOW AN EXPLORER OPENING A MYSTERIOUS STONE DOOR, ONLY TO BE GREETED BY A WEREWOLF!

WEREWOLF ATTACK! FIRST ATTEMPT

This version of the scene isn't terrible, but it's a little static and boring. The panels are all the same size. The "actors" are shown from a similar distance, and the viewpoints chosen do not do enough to create a sense of urgency or drama. The reader understands the story but is not drawn in.

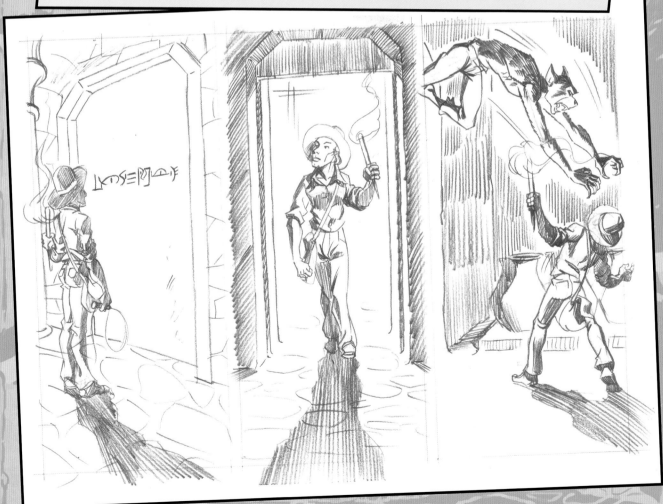

WEREWOLF ATTACK! SECOND ATTEMPT

This second version of the scene is much more exciting. The panel shapes are interesting, and close-up shots are mixed with longer shots and varied angles. However, there is so much going on that the scene has become confused. And what is happening in the last panel? Is it even in the same place?

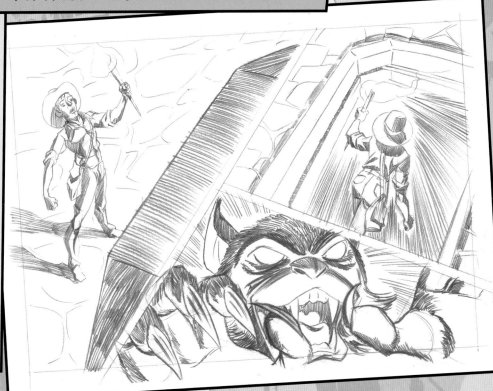

WEREWOLF ATTACK! THIRD ATTEMPT

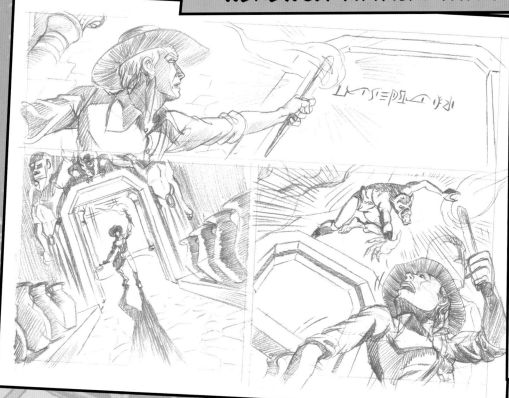

This third version of the scene gets the balance just right. The storytelling is nice and clear—it's not hard for the reader to tell what has happened. However, there is plenty of variation in the distance and angle from which we see the action, and there is a well-planned sense of drama and excitement.

HOW TO DRAW
A STORY PAGE

COMIC ART IS ABOUT MORE THAN JUST INDIVIDUAL IMAGES! A REAL COMIC ARTIST TELLS A DYNAMIC STORY THROUGH A SEQUENCE OF PANELS. IN THIS FINAL PROJECT, YOU CAN PUT TOGETHER ALL THE SKILLS YOU'VE LEARNED IN THIS BOOK TO CREATE A FINISHED COMICS PAGE.

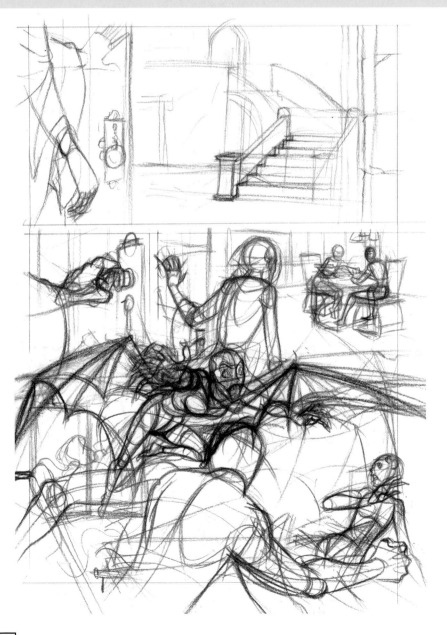

1 Decide what your story is and how many frames you need to tell it. Then create a rough sketch of the page. Don't try to fit too much into each frame. In our first panel, the scene is set with a character at the foot of a creepy staircase. In the second and third panels, they approach a door and open it to reveal what's inside. Then the main action happens in the final panel, when the character is revealed as a monster!

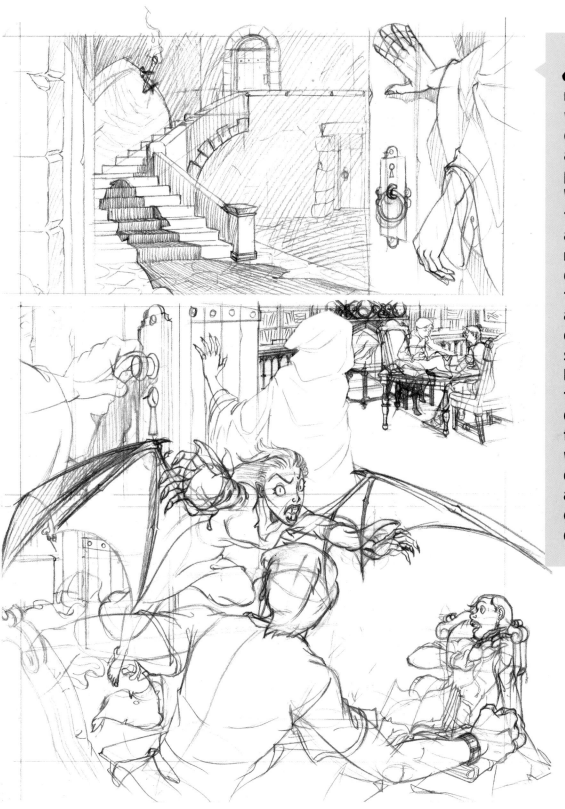

2 Take a careful look at your rough page. Do you want to make any changes before you add details to the pencil sketches? We decided to flip the first panel around, so that the reader's eye falls on the shadow on the staircase before anything else. This creates a nice sense of tension. Notice the way that the jumping character in the final panel overlaps with the top edge of the panel. It's an excellent way of giving a panel extra excitement.

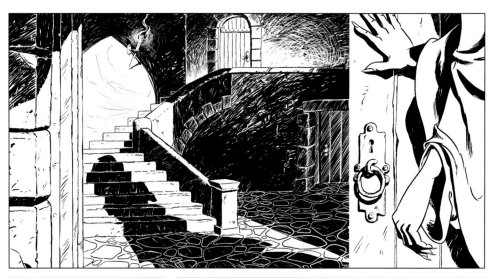

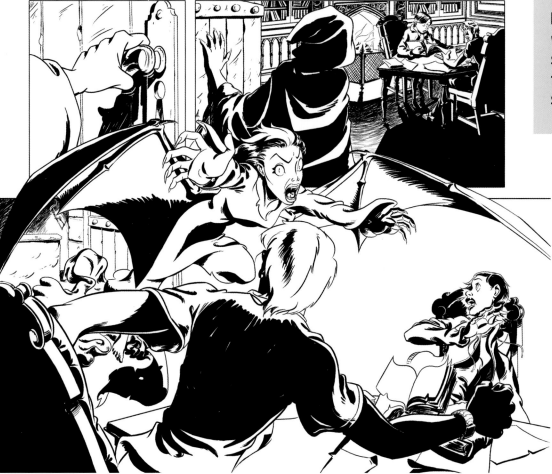

3 We've really gone to town with the shadows in the inking stage. By using plenty of black, you can show readers that this is a chilling tale and put them on edge. Notice that we have not lost any detail, though, because we have used narrow white lines to show shapes and textures within the shadowy areas.

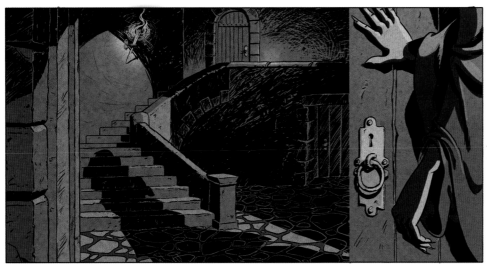

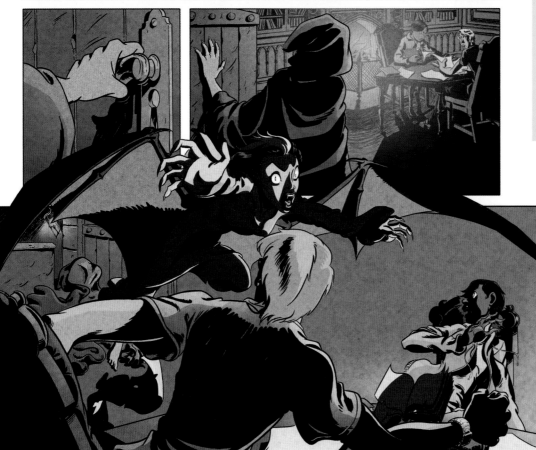

4 The color version of this story cleverly uses light and shade, too. Your eye seeks the detail in the top scene, and then it is drawn to the light farther down. Clever details, such as the yellow keyhole in frame two, link the panels together and give visual clues to what is happening and where the action is taking place.

DRAWING MALE FIGURES

YOUR COMIC CHARACTERS MAY COME FROM YOUR IMAGINATION, BUT THEIR BODY SHAPES WILL BE BASED ON REALITY. HERE ARE SOME RULES FOR PROPORTIONS THAT YOU CAN USE AS A GUIDE WHEN DRAWING.

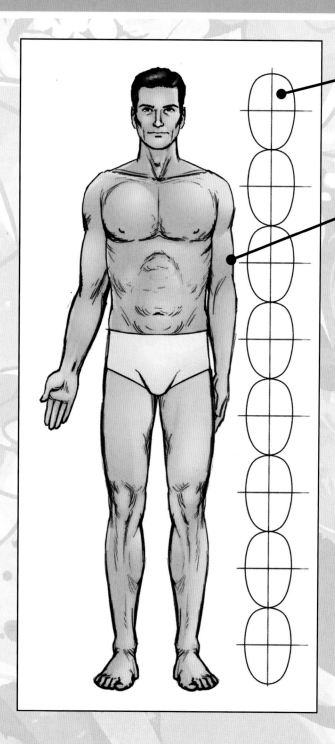

HEADS
Measure characters in "head heights." Typically, a person is eight times the height of their head, from top to toe.

ARMS
Make sure your character's arms are in proportion. Straightened, they should reach down to midthigh level.

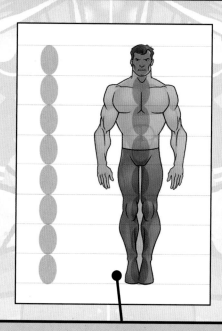

SUPERHEROIC BODIES
Superheroes have extra-broad shoulders, thick necks, and powerful arm muscles.

DRAWING FEMALE FIGURES

WOMEN HAVE A MORE SLENDER BUILD THAN MEN, WITH MUSCLES THAT ARE LESS DEFINED. THE NECK IS LONGER AND THE WAIST MORE PRONOUNCED. FEMALE CHARACTERS FOLLOW THE SAME "EIGHT HEADS" PRINCIPLE.

TORSOS
The distance from shoulder to hips should be about two-and-a-half "head heights."

SHOULDERS AND HIPS
Female characters' hips and shoulders are similar in width. Males taper from broad shoulders to a more narrow waist and hips.

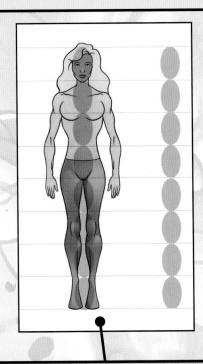

SUPERHEROINES
Superheroines do not have such large muscles as male superheroes, but their shoulders are broader than real women's.

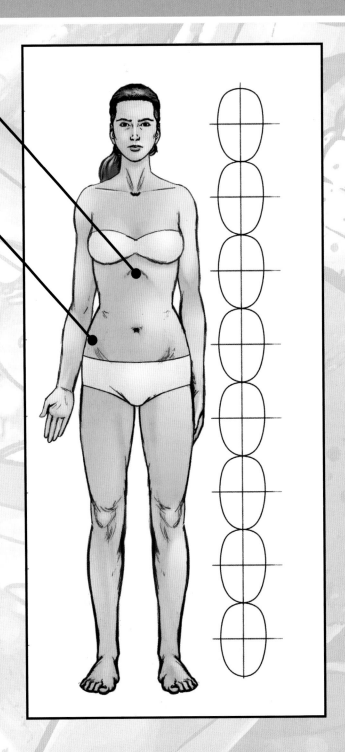

DRAWING HEADS

HERE ARE SOME GUIDELINES TO REMEMBER WHEN DRAWING HEADS AND FACES. THE BEST WAY TO HONE YOUR SKILLS IS TO DRAW REAL PEOPLE. IF NO ONE ELSE IS AVAILABLE, USE A MIRROR!

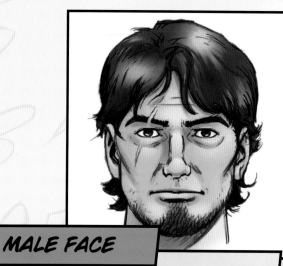

MALE FACE

The eyes are set lower in the face than you might imagine—about halfway down the head. The face is roughly five eye-widths wide.

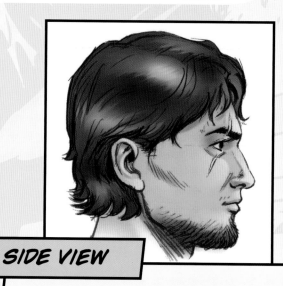

SIDE VIEW

Male heroes tend to have square jaws. Add shading for the cheekbones, but avoid drawing the outline of the top lip for men.

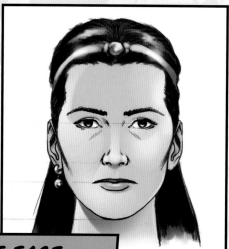

FEMALE FACE

Women's noses and mouths are smaller than men's, and their eyebrows are thin and finely arched. Female top lips can be drawn in full.

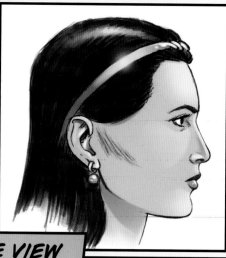

SIDE VIEW

Women have rounder jawlines than men. In both men and women, the ears should extend from the top of the eyes to the bottom of the nose.

PENCILS, INKS, AND COLORS

THERE ARE FOUR STAGES IN THE DRAWING PROCESS. IF YOU FOLLOW THIS METHOD, IT WILL SAVE YOU FROM SPOTTING BASIC MISTAKES WHEN IT IS TOO LATE TO FIX THEM!

ROUGH PENCILS

Start by making a rough sketch of your character. Work out their pose and proportions before adding any details.

TIGHT PENCILS

When you are happy with the basic frame, you can tighten it up with firm pencil strokes, then add in some shading.

INKS

Ink over your best pencil lines. Vary the thickness of strokes and add dramatic shadows. Then erase your rough lines.

COLORS

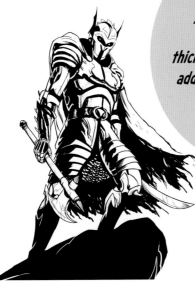

You can leave your drawings in black and white, or add color. The palette you choose will make a big difference to the tone.

INDEX